DOUG TAYLOR

TORONTO THEATRES

AND *the* GOLDEN AGE

OF THE SILVER SCREEN

Charleston · London

THE
History
PRESS

Published by The History Press
Charleston, SC 29403
www.historypress.net

Copyright © 2014 by Doug Taylor
All rights reserved

Images courtesy of the author unless otherwise noted.

First published 2014

Manufactured in the United States

ISBN 978.1.62619.450.2

Library of Congress CIP data applied for.

CONTENTS

CONTENTS

PREFACE

Several years ago, I commenced publishing a blog (tayloronhistory.com) about Toronto's Heritage Buildings and eventually included posts about Toronto's old movie houses. Seeking further information about the theatres of yesteryear, I searched for books to assist me, only to discover that very few were available. However, I secured a copy of John Sebert's book *The Nabes*, published in 2001. I thoroughly enjoyed it, as it excellently chronicled Toronto's neighbourhood theatres, referred to as "nabes," but it did not include the movie houses located in the city's downtown.

Most of us attended neighbourhood theatres only until we were of an age to travel farther afield. Then, as teenagers, the downtown movie houses became the main attraction. Attending them became high adventure. After all, few memories in life are more golden than those of our teenage years, and in the past, movie theatres played a major role during the formative years of many teenagers. To some extent, this remains true today.

Despite including the downtown theatres in this book, it is not a comprehensive study of the old movie houses of Toronto. There are too many to accomplish this within a single edition. As a result, I have selected a combination of downtown and local theatres, from the earliest days of cinema to the arrival on the Toronto scene of multiplex theatres and the Bell Lightbox, headquarters of the Toronto International Film Festival (TIFF). I retain fond memories of many of the theatres mentioned and have included personal anecdotes, as well as stories from those whom I interviewed.

While researching the old movie theatres, I discovered that much of the information has already been lost and that what remains is sometimes contradictory. The opening and closing dates for theatres are often in dispute, depending on the source. The records on file often disagreed on the number of seats in the theatres, as they frequently changed due to installing candy bars or being renovated to increase seating capacity. However, I consider these details inconsequential. My main purpose is to preserve the memories of attending these wonderful theatres. I have attempted to verify the information and consulted multiple sources wherever feasible, but this was often impossible. However, every effort has been made to ensure that the information is as accurate as possible. I also found that sometimes the information I discovered did not agree with my personal memories. This created difficulties when writing about the theatres. Some of the discrepancies I never resolved, leading me to think that my memory is not as accurate as I had previously thought. However, I must accept the blame for any errors contained in this book.

Similarly, due diligence has also been given to locate the sources and provide the proper credits for the photos that are included. If any are incorrect, I sincerely apologize and would be grateful to receive information to correct the errors. Future editions of the book and electronic versions would certainly include these corrections.

The files of the City of Toronto Archives were the most comprehensive, and I wish to gratefully acknowledge the expertise of the archive's staff, particularly Glenda Williams, whose knowledge of the files was amazing. In the Toronto Archives, the information and photos in the Ken Webster Collection and the files of Mandel Sprachman, which he generously donated to the archives, were particularly helpful. Mandel Sprachman (1925–2002) was the son of Abraham Sprachman (1896–1971), who designed many theatres in Toronto in partnership with Harold Kaplan (1895–1973).

On the Internet, sites such as www.blogtoronto.com and www.silenttoronto.com were excellent sources of reference. The picture collection of the Ontario Archives was superb, and staff generously allowed me to access the collection. This book would not have been possible without all these sources. As well, when posts about the theatres were placed on my blog, those who possessed personal knowledge of the theatres sometimes contacted me and offered further information or corrections. I am grateful to those who took the time to contact me.

It is predicted that in the future, the number of movie theatres in Toronto may dwindle. Film studios are discovering that it is financially

more profitable to release movies directly to electronic formats. In the years ahead, it is likely that only big-budget blockbuster films will be viewed in theatres. This is a pity. A major part of the movie experience is viewing films on a large screen, accompanied by a superb audio system, and sharing the experience with others.

At TIFF in 2013, I attended a screening in the Princess of Wales Theatre. It revived memories of my youth, when I watched films in the Imperial, University, Loew's Downtown, Tivoli and Uptown. I had forgotten the emotional impact of viewing a film as part of an enormous audience, where everyone shares the pain and sorrow, as well as the laughter and amusement, of the characters on the screen. Television and electronic devices have their place, but they are a poor substitute for the big-screen experience.

This book is an attempt to recall those golden days, when local theatres and the large downtown movie palaces were the centres of Toronto's entertainment scene. If you are able to recall these theatres, it is hoped that this book will create fond memories. For those who never knew them, perhaps this book will allow them to capture a glimpse of the rich history represented by the grand old theatres of Toronto's past.

INTRODUCTION

The young woman was trapped inside the sleek black coupe as it crashed through the guardrail beside the cliff's edge and jettisoned into space. Within seconds, losing its momentum, it plunged to the rock-strewn coastline below. Crashing onto the rocks, it was transformed into a heap of crumpled metal. Curious gulls circled the wreck, their shrieks mingling with the crashing surf.

My eyes were glued to the screen as eerie music increased in volume. Then, through the lens of the camera, I was drawn downward to the mangled wreck. I was scared stiff. I did not wish to gaze inside the car at the women's battered body. I knew that her husband had murdered her by tampering with the automobile's brakes.

The scene was to haunt me for weeks.

This melodramatic description, akin to that of a pulp murder mystery, describes my introduction to the drama of the silver screen. In 1943, at five years of age, I saw the movie described above when I attended my first Saturday afternoon matinee. When I was a child, nothing rivalled the thrill of a matinee. It was unlike any other event in the week, akin to a hallowed ritual. Through the magic of movies, I was exposed to faraway, exotic worlds, as well heroes of the past, superheroes of the present and space adventurers of the future. Cowboys, crime-stoppers, criminals and pirates all raced across the screen.

Matinees involved far more than simply films. They were gathering places for our entire neighbourhood. I might also mention that at matinees, I surreptitiously watched the older kids doing things in the back rows

that I thought that I might like to do, and I yearned to attend an evening performance, as I suspected that the back rows were even busier. However, constrained by my youthful age, I claimed the Saturday matinees as my private pleasure domain instead—I cheered, screamed and booed in a manner that my parents would never have allowed if they had been present. The back-row pleasures were to wait for a few years.

When I was a boy in the 1940s, every neighbourhood possessed a local movie house, sometimes several. We walked to them, as few families owned automobiles, and carfare (TTC tickets) was considered expensive, since tickets cost three cents each. The matinees commenced at 1:30 p.m. and ended around 5:00 p.m., all for the price of ten cents. Before the matinees began, to distract us and prevent us from becoming rowdy, the management flashed the lyrics of well-known war songs on the screen—"Bell Bottom Trousers, Coat of Navy Blue" and "Pack Up Your Troubles in Your Old Kit Bag"—and we chorused in rowdy voices that rang to the rafters. When the songs ended, the curtains closed, and we knew it was time for the afternoon's first movie feature to begin. After a dramatic pause, the curtains majestically swept open once more to thunderous cheering, yelling and whistling. The title of the first movie flashed across the screen. The horrific screaming continued throughout the screen credits, until the words "Directed by…" appeared. We then became quiet, as the movie was to commence.

The format of the matinees was similar throughout the city. The first film of the afternoon was followed by the "trailers," which were the advertisements for future film attractions. Then there was a newsreel, which invariably showed scenes of the war front. These were followed by a cartoon. Perennial favourites included Mighty Mouse, Daffy Duck, Speedy Gonzales, Bugs Bunny, Tom and Jerry, Sylvester the Pussycat, Yosemite Sam, Porky Pig, Woody Woodpecker, the Road Runner and Elmer Fudd. I might add that commercials were rare. The only one that I remember was for Chiquita Bananas, the jingle sung by Carmen Miranda. I can still picture her huge hat with its array of tropical fruits.

Next they showed a serial, which was a short film that required five or six episodes, one shown each week, before the entire tale was completed. Serials were also referred to as "movie-chapter plays" or "cliff hangers," the latter name coined because the heroes were sometimes left hanging on a cliff when an episode ended. Most of the serials were westerns or involved crime fighters. My favourites were Lash LaRue, the Cisco Kid, Don Winslow of the Navy, Dick Tracy and the Green Hornet. Following the serial, they screened the second feature film of the afternoon. When the matinee ended,

I could hardly wait to view the films that had been advertised in the trailers for the following Saturday.

When I became too old to attend Saturday afternoon matinees, one of the great delights of childhood came to an end. Looking back, I realize that the loss of kids' matinees from my life was as big a loss as not going "shelling-out" (now referred to as "trick or treating") on Halloween or no longer receiving toys under the Christmas tree. Shirts, ties, handkerchiefs, books and trousers never created the same delight as toys, puzzles and board games. Similarly, when I became an adult, attending movies never created the same thrill that the Saturday afternoon matinees of my youth generated.

Fortunately, compensation was on the horizon. As I grew older, I became of age to attend movie theatres located beyond our neighbourhood. In Toronto, most of them were on main arterial streets such as St. Clair Avenue, Bloor Street, the Danforth, Parliament Street, Bayview Avenue, College, Gerrard or Queen Street. For our neighbourhood, the theatres on St. Clair and Oakwood Avenues were the big attraction. Then, when we became teenagers, we hit the "big time": the theatres on Yonge Street or in proximity to it.

My final cinematic thrill was becoming of age to view adult (restricted) films, this classification on the billboard an enticement to attend some of the worst movies ever filmed. Often, the billboard pictures outside the theatres revealed more skin and sin than the films on the screen. Modern advertisements employ the same techniques on television and the Internet. It seems that exaggeration to promote a product is not restricted to any era.

In the late 1940s and early 1950s, movie theatres were "king." That was to change as television appeared on the entertainment scene. At first, TV was a novelty, and purchasing one was beyond the finances of most families. Appliance stores placed TV sets in their windows and hooked up speakers outside their shops to entice people to stop and view the programs. It was a highly successful sales technique, even though the pictures were black-and-white and quite grainy—the interference on the screen was referred to as "snow." Programs varied in quality, as most of them were broadcast live. If a family purchased a set, a rooftop aerial was required to receive the broadcast signals from Buffalo. The local CBC station was available via a "rabbit-ear" antenna. TV stations commenced broadcasting test patterns one hour before the programming began at 5:30 p.m.; broadcasting ended shortly after 11:00 p.m., when they played the national anthem. Despite these drawbacks, many longed to have TVs in their living rooms.

No one realized that a single event would alter the world of entertainment forever. In June 1953, the coronation of Queen Elizabeth II was televised, the first time in history it had ever been captured by TV cameras. The films of the royal event were flown by jet across the Atlantic and broadcast the same day across the nation on television. Coloured films were also screened in several of the city's movie theatres, but it was the attraction of viewing the ceremony within the privacy of one's home that sent thousands to the stores to purchase TVs. Our family bought a seventeen-inch-screen Westinghouse and felt that we possessed our own movie screen in our living room.

It was not long before TV began to change Toronto's entertainment scene. As the number of TV screens increased, attendance at movie theatres declined. Then, in 1954, the first TV programs in colour were broadcast in the United States. It was to be several years before they appeared in Canada, and the quality of the pictures was quite crude compared to today; still, the advent of colour television diminished the one major advantage the movie houses possessed: films in colour. As television improved, attendance at movie theatres diminished further.

By the mid-1960s, the majority of the neighbourhood theatres had closed. The downtown movie houses fared better, as they were located in more populous areas and attracted suburban crowds. Today, only a handful of the old theatres remain—the Fox, Kingsway, Revue, Royal, Mount Pleasant, Regent and Humber. By the 1970s, television had replaced the movie theatres as the king of entertainment. Who could ever forget the soft-core porn films, called "Baby Blue Movies," shown on late-night TV? The world had indeed changed.

Today, Toronto is known as one of the great film-viewing centres of the world. The Toronto International Film Festival clearly demonstrates the city's love affair with the silver screen. Thousands of people stand in line each year to view the numerous films that the festival offers. Despite TV and the modern devices on which films can be viewed, many Torontonians continue to love the "big-screen experience."

Where and when did Toronto's romance with movies begin?

THE EARLY YEARS

Nickelodeons and the First Theatres in Toronto

The city's first silver screen experience occurred on the southeast corner of Yonge and Adelaide Street East. Today, a high-rise tower of glass and steel exists on the site. In the final decade of the nineteenth century, this was the site of Robertson's Musee. When it opened in 1890, it offered magic acts, jugglers, musicians and aerialists, as well as a curio shop. On the second floor was a wax museum, and on the roof were cages with live animals. Some might be tempted to compare it with Toronto's city hall of today.

This quaint establishment became the first venue to offer a new attraction that was to change the entertainment scene of Toronto forever. On August 31, 1896, Robertson's Musee commenced showing "moving pictures," projected by a Vitascope, an invention of Thomas Edison. The movies were quite simple compared to the films that would appear in future years. A showing consisted of a series of brief films, each running less than one minute. Some of the clips simply depicted a man galloping past on a horse or an automobile appearing on the scene and then disappearing. Despite the quality of the films being poor, a newspaper reported that "the machine projects apparently living figures and scenes on a canvas screen…it baffles analysis and delights immense audiences."

Robertson's Musee would change hands in the years ahead and was managed by different proprietors. In 1899, the property was sold, and it became the location of a Shea's Theatre. Unfortunately, the building that housed the Musee at Yonge and Adelaide was destroyed by fire in 1905.

THEATORIUM (RED MILL): TORONTO'S FIRST MOVIE EXPERIENCE AND FIRST PERMANENT MOVIE THEATRE

After Robertson's Musee introduced the world of film to Toronto, other establishments realized the possibilities of the new form of entertainment. In the months ahead, in the downtown area, small shops and the backrooms of stores were converted for screening films. A large piece of white canvas or a bedsheet was attached to a wall to serve as a screen, and patrons sat on kitchen chairs or stood to watch the films. The proprietors soon realized that permanent locations were needed, where they could offer more space, a proper screen and better seating.

In March 1906, Toronto-born John C. Griffin opened Toronto's first permanent space for showing moving pictures, located in rented premises at 183 Yonge Street. He named his theatre the Theatorium. The 150-seat theatre possessed a mere seventeen-foot frontage on Yonge and a depth of only one hundred feet. It was on the east side of the street, a short distance north of Queen Street. The first feature shown was an Edison Production, *The Train Wreckers*, released in 1905. Griffin offered several vaudeville acts to accompany each screening at the Theatorium, a formula copied by the theatres that followed in Griffin's wake. Around the year 1912, the Theatorium was renamed the Red Mill. Today, the Elgin/Winter Garden complex at 189 Yonge Street is located on a portion of the site.

In April 1913, a poster in front of the Red Mill Theatre advertised the film *The Red Girl's Sacrifice*. A boy was seen leaning against a hydro pole in front of the theatre, gazing intently at the poster with a sullen look on his face, as he did not have a nickel to enter the theatre. However, even if he had possessed the five-cent admission price, he knew that his parents would not have approved of him entering. In this era, many of the churches condemned movie houses, as they considered them "dens of iniquity." Educated people considered films low class and vulgar, attended by people of dubious moral standards.

This attitude prevailed because the theatres that began showing movies, including the Red Mill, were also vaudeville houses, where comedians told risqué jokes, and some were burlesque houses that featured scantily clad women on their stages. Many members of the clergy pontificated about the evil influences of movie theatres. In an attempt to create a degree of respectability, the owners of the theatres referred to their films as "photo plays," in an attempt to link them to the legitimate stage performances of the day. This was never truly effective, as even into the late 1930s, many churches continued their opposition to movie theatres.

AUDITORIUM (AVENUE, PICKFORD)

With the success of the Theatorium (Red Mill), other entrepreneurs commenced seeking rental properties to create permanent theatres. When choosing a site, it was important that it be centrally located, the rent be reasonable and the property contain generous space for seating. They also attempted to minimize the number of employees to reduce expenditures. In most venues,. balconies were not viewed as desirable, since patrons were reluctant to climb the stairs and the support columns of the balconies blocked sightlines in the auditoriums. Other concerns included the danger of fire, as films generated considerable heat as they threaded through the projectors. There was also the danger of a fire caused by a careless smoker. Teenagers were seen as another problem, not only because of their smoking but also due to their rowdy behavior. Other difficulties that faced theatre operators were the constant hassles of the film censors and the morality squad, as well as the problems of underage kids sneaking inside to view the movies. However, because the profits were lucrative, the number of theatres steadily increased.

One of the theatres that was contained in a rental space was the Auditorium Theatre, at 382 Queen Street West. It opened in 1908 on the northwest corner of Queen Street and Spadina Avenue, its entrance on Queen Street. It was an ideal location since both streets possessed much foot traffic, and two of the busiest streetcar lines in the city—the Queen and the Spadina lines—passed by its doors. The theatre occupied the ground floor of the three-storey Moler Barber Building. The theatre contained 356 seats but no balcony, although it included a stage to accommodate live theatre and vaudeville acts, this format having been copied from the Theatorium. The floors above the theatre contained offices and residential apartments.

The theatre was immediately successful. It was renovated in 1913 and its name changed to the Avenue. The auditorium was extended to the north, increasing the seating capacity to 456 seats. The entrance was also improved to attract more customers.

The theatre was renamed the Pickford in 1915 in honour of Mary Pickford. Born in Toronto, by 1915 she had become a rising star on the Hollywood scene. Her real name was Gladys Marie Smith, but she changed it to Mary Pickford when she appeared on Broadway in 1907. Her film career began in 1909, and her final silent film was in 1927. She was known as "America's Sweetheart" and became the first truly international star of the silver screen. At the Academy Awards of 1929, she won the Oscar for

Best Actress for her role in *Coquette*, which was a "talkie," as sound films were called. She was one of the founders of the Academy of Motion Picture Arts and Sciences, which was (and remains) responsible for the Academy Awards. Mary Pickford and her husband, Douglas Fairbanks, in partnership with Charles Chaplin and D.W. Griffith, were the creators of United Artists Studios. Mary Pickford and her husband were also the first stars to officially place their footprints in the cement in front of Grauman's Chinese Theatre. Mary Pickford died in 1979.

During the First World War, the Pickford Theatre entertained many of the troops who were waiting to be sent overseas. In the decades ahead, although the theatre continued to draw crowds, it became evident that screening films on the ground floor of a rented premise had serious drawbacks. The ceiling was too low to allow a large screen to be installed, and there was insufficient space to build a balcony without large support pillars. As a result, increasing seating capacity to improve revenues was limited.

In January 1938, water-washed air cooling was installed in the Pickford to create a more comfortable environment during Toronto's humid summers.

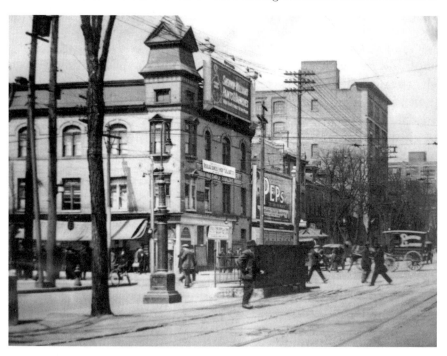

The Moler Building, where the Pickford was located. *City of Toronto Archives, Fonds 1244, Item 1157.*

After the theatre closed, in the years ahead, the building would be occupied by Bargain Benny's. Eventually, the Moler Building was demolished, and a small café was constructed on the site. A McDonald's restaurant is now (2014) located where the Pickford Theatre once stood.

It is impossible to discover the number of small theatres that opened in Toronto in rental spaces during the early decades of the twentieth century. Many of them were not even listed in the Toronto directories—only the buildings in which they were located were mentioned. The Pickford remained in operation for several decades, so it is one of the few that is well documented.

In the photo on page 18 that depicts the Moler Building on the northwest corner of Queen and Spadina, the Pickford was on the ground floor. The view is looking north on Spadina about 1920.

COLONIAL (PHOTODOME, ACE, BAY)

The next advancement in theatre history occurred in 1909, when a building was constructed for the exclusive purpose of screening moving pictures. Located at 45 Queen Street West, it was to the east of the intersection of Bay and Queen West. It was named the Colonial Theatre and later was renamed the Bay. Although it was in a separate building, its heating system was connected to the Simpson's Store (now the Bay Store), which occupied most of the city block on the south side of Queen Street, between Yonge and Bay Streets. The theatre possessed no basement. It was directly across from Toronto's city hall, today the Old City Hall, an advantageous location because it was in the heart of the city's retail district.

An architectural sketch in the Toronto Reference Library reveals that the theatre possessed a two-storey symmetrical Neoclassical-style façade of brick and stone, with a conglomeration of fluted columns, arches, pilasters and a heavy ornate cornice. Its auditorium had about 230 velour-covered leatherette seats, with slightly over 100 in the mezzanine, as well as about 130 in the balcony that wrapped around the auditorium. On the ground floor, there were two aisles and more aisles along the side walls. Stairs on the east side led to the mezzanine level, and a set of steel stairs gave access to the balcony. The projection booth was atop the balcony, in an area referred to as the Gallery.

In 1915, the name of the theatre was changed to the Photodome. In 1919, the building's height was extended by two storeys. The addition was built

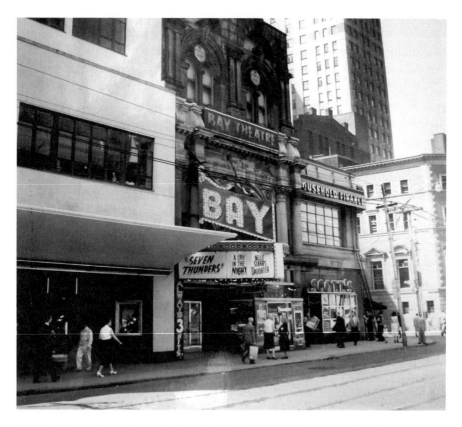

The Bay Theatre (formerly the Colonial) in May 1959. *York University Archives,* Toronto Telegram, *photo by Woods.*

from stones, brick, columns and so on from the demolished customhouse on the southwest corner of Front and Yonge Streets. The original façade of the theatre was already impressive, but the addition created a building that appeared top-heavy. The windows on the second floor were massive, containing ornate surrounds.

In 1941, the theatre was closed for renovations and reopened on September 1, 1941, as the ACE Theatre. For the occasion, it offered a midnight show, a novel idea in this decade. The name ACE had also been employed for a theatre on the Danforth, but there was no connection between the two theatres. In the 1940s, the ACE on Queen Street was owned by Sam Ulster, who also owned the Broadway on Queen Street and Rio Theatre on Yonge Street. He was also the owner of the Town and Country Restaurant on Mutual Street. I remember this eatery very well. It was famous for its buffet,

which featured roast beef and lobster. Its main rival in the 1940s was the Savarin Tavern on Bay Street.

In 1942, the lobby of the ACE Theatre displayed sandbags and weapons to draw attention to the war effort and to encourage the purchase of war bonds. In 1950, the theatre was extensively renovated, and when it reopened, its name was changed to the Bay. It survived in the years ahead by showing B-films, usually offering three features for a single admission price. However, in the 1960s, Simpson's Department Store required space to expand and purchased the property. The theatre was demolished in 1965 and the Simpson Tower constructed on the site.

My memories of the theatre that was later renamed the Bay commenced in the 1940s, when my family lived in York Township, which in that decade was a suburb of Toronto. Each year at Christmas, my mother travelled to downtown Toronto to shop at Queen and Yonge Streets, where Eaton's and Simpson's Department Stores were located. My brother and I always accompanied her on these visits. We travelled on a Bay streetcar to Queen and Bay Streets and walked one block east to Yonge Street. I often gazed at the impressive façade of the theatre on the south side of Queen. In the 1940s, to the west of the theatre was a restaurant named Bowles Lunch, the space later occupied by Scott's Chicken Villa.

As a child and later as a teenager, I was unaware of the importance of the Bay Theatre and did not appreciate that its construction was a milestone in the history of Toronto's theatre scene.

REVUE

Following the success of the downtown theatres, it was not long before they began to appear in the communities surrounding the inner city. One of the first theatres built outside the downtown area was the Revue. Located in the Roncesvalles District, it was in a rapidly developing middle-class residential area. Jacob Smith built the Revue Theatre at 400 Roncesvalles Avenue between the years 1911 and 1912. Located on the west side of Roncesvalles Avenue, it was a short distance south of Howard Park Avenue. The theatre's 543 seats were originally covered with Fabricord, but the seats were replaced in 1945 by the Canadian Theatre Chair Company. In the same year, the number of seats was reduced to 524. In 1955, the two back rows of seats were removed to allow a candy counter to be installed. At one time, the

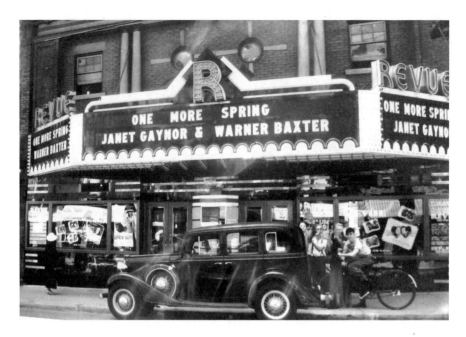

The Revue Theatre in 1935. *City of Toronto Archives, Fonds 251, Series 1278, File 140, Item 001.*

theatre was owned by the Associated Group, which later became 20th Century Theatres.

During a severe snowstorm, one of the sets of lights on the marquee that spelled the name of the theatre fell to the street. Today, it remains in a storage area located behind the screen. Eventually, the entire marquee was removed, as it was too expensive to maintain. However, except for the loss of its marquee, the façade of the theatre remains unchanged since it first opened.

In the City of Toronto Archives, a notation in the file of the Revue Theatre states that in 1959, an inspector discovered that a sixteen-year-old had entered the theatre, at a time when the legal age was eighteen. The teenager was ejected and his money refunded. An incident such as this was considered scandalous in this era.

Today, the Revue is an integral part of the Roncesvalles neighbourhood, having been an active theatre for more than a century. The theatre has survived through the support of the community that surrounds it, which rallied to keep it open as a functioning movie house.

PICTURE PALACE (ROYAL GEORGE)

In the early years of the twentieth century, the Earlscourt District, which centred on St. Clair Avenue West and Dufferin Street, was isolated from the downtown core of Toronto by the steep incline of the enormous hill above Davenport Road. It was 1913 before streetcars serviced the area. Travelling downtown to view a film was a considerable journey.

About the year 1912, Mr. A. McCullock realized the possibilities of the area for a movie theatre and built the Picture Palace on the southwest corner of Dufferin and St. Clair Avenue West. It was a three-storey red-brick building, the auditorium of the theatre the equivalent of two-storeys in height. Residential apartments occupied the third floor, their rental income helping to offset the operating costs of the theatre.

Several years ago, I interviewed a lady who was over ninety years of age at the time. She had lived on Rosemount Avenue, located two blocks south of St. Clair, west off Dufferin. As a child, her family attended a church that worshipped in a small hall beside the theatre, on its west side. She often passed the Picture Palace and gazed at the advertisements for the films outside the theatre. Her parents had warned her never to enter the theatre, as they considered it a sinful place. However, because laws did not permit

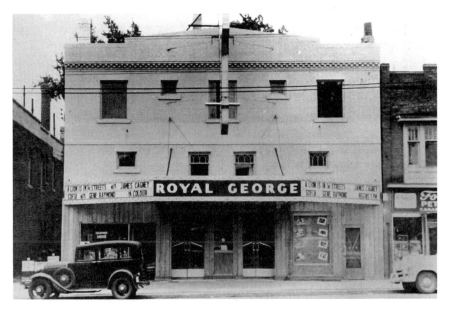

The Royal George in September 1954. *City of Toronto Archives, Fonds 251, Series 1278, File 146, photo by Harvey R. Naylor.*

movies on Sundays, the theatre remained empty. Her church often rented the premises for special musical programs and religious campaigns. She was inside the theatre many times on these occasions. She said that she often wondered what nefarious deeds occurred within the building during the week, when movies were shown.

During the First World War, the Picture Palace continued to operate from its corner location. However, its owner eventually decided to relocate farther west along the street. The original building remains in existence today. Because the auditorium of the theatre was aligned east–west, parallel to the street, after the theatre relocated it was easy to convert the building to small shops that faced busy St. Clair Avenue.

The theatre that replaced the old Picture Palace was farther to the west, at 1217 St. Clair. Due to the patriotic fervour created by the war, and because the area was inhabited mostly by British immigrants, the name of the theatre was changed to the Royal George. Its owner remained Mr. A. McCullock. His new theatre contained 456 seats, fewer than in its former location. There was a billiard parlour on the third floor, with the stairs ascending to it on the west (right-hand) side of the theatre entrance. A shop was on the left-hand side of the entrance. The front of the building was symmetrical, with a parapet above a cornice that consisted of rows of bricks that resembled dentils. To the east of the theatre was a laneway that has since disappeared.

A file in the Toronto Archives states that several years ago, a woman was interviewed whose mother was employed as a cleaner at the Royal George Theatre in 1919. She stated that her mother, when cleaning the auditorium, always lifted the seats to clean under them and was delighted if she discovered a nickel or penny that had dropped to the floor. When she worked at the Royal George, Mrs. McCullock operated the theatre, as her husband had passed away. Mrs. McCullock sold tickets in the ticket booth, where she always placed a bouquet of fresh flowers. The woman's mother said that Mrs. McCullock was very kind, and on one occasion, she purchased a winter coat for her.

The Royal George remained a thriving theatre for many decades, even after the St. Clair Theatre opened one block to the east in 1921. However, in a situation similar to most of the city's old theatres, the age of television diminished the crowds. In September 1954, the theatre was for sale for the price of $147,000, but it remained a functioning theatre for another decade. It eventually closed and was converted into retail shops.

BIG NICKEL (NATIONAL, RIO)

While movie theatres such as the Picture Palace were being built in the suburbs surrounding Toronto, more were appearing in the downtown area. One of these was the Big Nickel Theatre, a relatively unpretentious theatre located at 373 Yonge Street, a short distance south of Gerrard Street. It opened in 1913. The 478-seat theatre contained a concrete floor with a wood covering. Wooden stairs led to the basement, where the washrooms were located. The second floor was rented for other purposes, which was typical in this era. This was especially important on Yonge Street, where property prices and rental charges were expensive. In 1939, the theatre was renovated under the plans of Jay English and renamed the National. In 1951, it was again renovated, this time by Kaplan and Sprachman, and renamed the Rio.

Throughout the years ahead, there were many problems at the Rio, as it was located on a busy section of Yonge Street that attracted a diverse crowd. In April 1948, there were complaints that people were smoking throughout the theatre, and one patron complained, "Three people in front of me smoked five cigarettes during each performance, passing lighted matches from one to another...a man across the aisle butted a cigarette under the seat, close to the edge of the carpet and allowed it to burn out." In 1951, there were complaints of teenagers throwing lighted cigarettes into the air. As a result of these infractions, the theatre hired a plainclothes detective to maintain order.

In 1953, for a special photo night, the theatre hired a master of ceremony. A patron complained, saying, "I did not come to the theatre to hear such lewd tales," and "I was shocked at the filthy obscene jokes." Then the patron added, "Perhaps the M/C needs his filthy mouth washed with soap."

The theatre manager replied, "I was not aware that the M/C was going to tell these types of stories, and it was not done with our approval."

I never attended the Rio because I was a suburban kid in the 1950s, and if I travelled downtown to attend a movie house, I wanted to see the latest films that Hollywood offered. The movies at the Rio were available in my neighbourhood theatres.

In the latter years of the Rio's existence, it showed four films consecutively before repeating the sequence, beginning at 9:00 a.m. and continuing until 4:00 a.m. Because the admission price was cheap, and due to the long hours it remained open, it became a favourite place for the homeless to escape the cold or to recover from the effects of inebriation before they returned to the street. Thus, it gained a reputation as a hangout for "rubbydubs," as

teenagers referred to drunks in that decade. During this period, prostitutes on Yonge Street, while soliciting clients, often huddled in the doorway of the Rio to escape the winter winds.

The theatre deteriorated to such an extent that, prior to its closing in 1991, the seats were extremely tattered, and plaster was falling from the ceiling where a heating coil had broken and leaked water. As well, there were tears in the screen, where it appeared as if the actors were dodging around the holes. The Rio has now disappeared from the Yonge Street strip, but the building remains.

In 2014, an adult video and novelty store occupied the site.

MADISON (MIDTOWN, CAPRI, EDEN, BLOOR CINEMA, BLOOR HOT DOCS)

One of the finest theatres built during the early years of the twentieth century opened in the Annex District of Toronto. It was where the Bloor Hot Docs Cinema exists today, at 506 Bloor Street West. The original theatre on the site opened on December 23, 1913, and was named the Madison. Its 636-seat auditorium and 461-seat balcony boasted plush upholstered seats with matching backs in an era when most seatbacks in theatres were of wood. The theatre offered stage attractions, silent movies and eventually sound films. The Madison was highly attended throughout the 1920s and 1930s, even though it did not feature the most current movies of the day.

In 1940, the Madison was purchased by 20th Century Fox and demolished, except for the two side walls. The architectural firm of Kaplan and Sprachman designed the new theatre. When it reopened in May 1941, its name was changed to the Midtown. Usherettes were introduced one month later, causing quite a sensation, as the head usherette had been Miss Hamilton of 1939. During the late 1940s, the Midtown specialized in horror films.

In 1967, its name was changed to the Capri, and in 1973, it became the Eden. It then featured porno films that by modern standards were quite tame. It ceased screening these films in 1979, and the theatre reverted to showing regular films. Because it did not attract sufficient crowds, it was closed on November 14, 1980. It was taken over by the Festival Cinema chain, which owned the Fox, Kingsway, Music Hall, Revue and Royal Theatres. The chain reopened the theatre at 506 Bloor Street in 1981 as the Bloor Cinema, and similar to other theatres in the chain, it specialized in

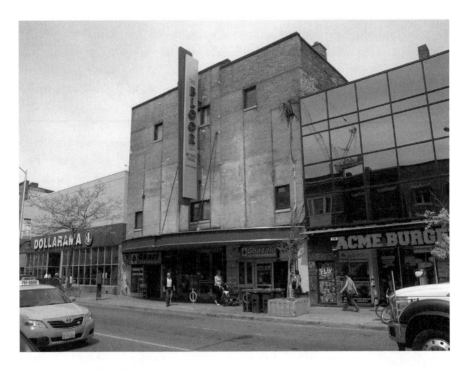

The Bloor Hot Docs Theatre in July 2013.

B-movies and second-run features. It also offered cheaper prices at its snack bar. In 2010, Carm Bordonero and his brother, Paul, purchased the building to ensure that it would survive as a functioning theatre.

In 2011, the operation of the theatre was sold to the Blue Ice Group. After a $3 million renovation, it was reopened on March 16, 2012, as the Bloor Hot Docs Cinema. Today, the theatre is a venue for the Hot Docs Festival, one of the city's largest film festivals. When the festival is not in season, the theatre presents an excellent assortment of documentary films. The city of Toronto is greatly enriched by the survival of this historic movie house.

THEATRE WITH NO NAME (PASTIME, PRINCE EDWARD, FOX)

Construction on the Fox Theatre, located at 2236 Queen Street East, commenced on October 20, 1913, and it opened the following year. It was originally called the Theatre with No Name, likely the only theatre in

Toronto that officially opened without a designated name. The land to build the theatre was purchased for thirty-five dollars per square foot. The permit allowed the construction of a three-storey brick building, with apartments on the second and third floors. It contained 750 seats and a large marquee that dominated the street. On opening night, a four-piece musical group was hired to accompany the silent film *Squaw Man*.

A few months after it opened, a contest was held to give the theatre a proper name, with the winner to receive twenty-five dollars in gold. The winning name was the Pastime, and the marquee was changed on April 19, 1914. The following January, another contest was held, which resulted in the

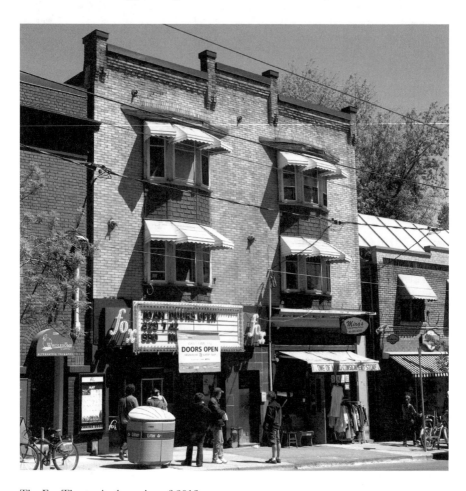

The Fox Theatre in the spring of 2013.

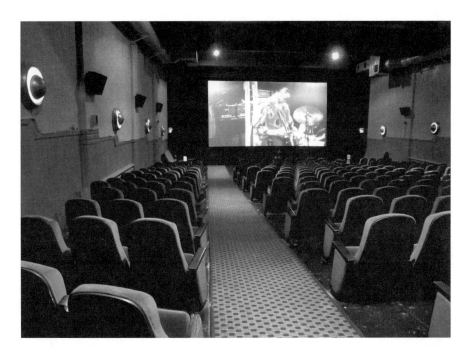

The auditorium of the Fox Theatre in 2013.

theatre being renamed the Prince Edward, in honour of the Prince of Wales, who would later become King Edward VIII. The choice of name reflected the patriotic fervour that dominated Toronto during the First World War, and it was felt that the new name might aid in recruitment—during the war, recruitment meetings were held in the theatre, as well as silent movie showings.

In February 1929, the theatre was converted to facilitate sound films. No matinees were held, and of course, no films were shown on Sundays.

When King Edward VIII abdicated the throne in 1936, the theatre became the Fox. The name evoked memories of the famous Fox Theatre chain in the United States, but there was no connection. The same year, the lobby was redesigned by Jay English.

The Festival Cinema chain purchased the property in 1978, two years prior to the company buying the Bloor Theatre (the old Madison/Midtown Theatre). In 1980, the Fox Theatre screened *The Rocky Horror Picture Show* at midnight and continued showing the film for an extended period. In 1981, the Fox became a repertory theatre. Sadly, the marquee was removed from the front of the theatre, as it was too costly to maintain.

Today, the Fox Theatre is one of the oldest theatres in Toronto that remains an active movie house. Early one morning in 2013, I travelled on the streetcar to the Fox Theatre to photograph it. I discovered that from Yonge and Queen Streets, it required fifty minutes to arrive at the theatre. This allowed me to understand how isolated the theatre was from downtown Toronto when it opened in 1914.

PART II

THE GREAT MOVIE PALACES

The End of the Nickelodeon

LOEW'S YONGE STREET (ELGIN/WINTER GARDEN)

The financial success of the movie theatres in Toronto soon drew the attention of big investors and men who became known as "movie moguls." They introduced opulent theatres that people referred to as "movie palaces." One of these grand theatres was nearing completion as the year 1913 was drawing to a close. Located on Yonge Street, a few doors north of Queen Street, its construction had commenced a mere eight months earlier. Commissioned by the American financier Marcus Loew, the complex contained two full-sized theatres, one located above the other. Their opulence was proof of the truth of Loew's motto: "We sell tickets to theatres, not movies."

Designed by the New York architect Thomas W. Lamb (1871–1942), the venues were intended as the Canadian flagship theatres for the expanding chain of vaudeville and film theatres of Marcus Loew, who owned twenty-five theatres in New York City. The new theatres on Yonge Street were among fewer than a dozen "stacked" theatres built in North America and the only location in Canada that remains in operation today. Two survive in the United States.

Even in 1913, frontage on Yonge Street was extremely expensive. As a result, Marcus Loew purchased only a small amount of land facing the busy street. The price at the time was considered astronomical—$600,000. The concrete reinforced structure cost an additional $300,000. The narrow,

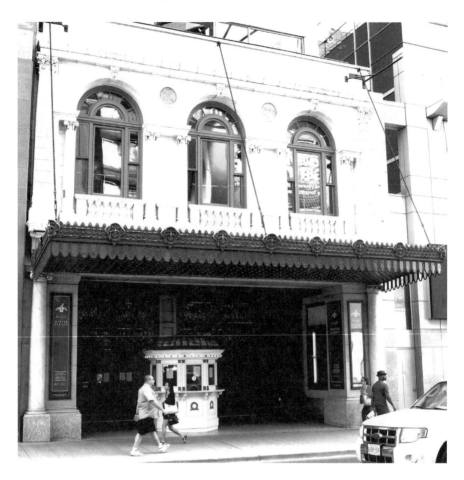

The Elgin/Winter Garden Theatre Complex in 2013.

elegant entranceway leading from the front doors on Yonge Street to the theatres was aligned west–east, and the auditoriums within were aligned north–south. This arrangement reduced the need for a large portion of the site to actually be on Yonge Street. The elongated entrance hallway was useful in providing shelter for lineups on rainy days or during the winter season. The hallway was decorated in the classical style, similar to a great European palace. It contained enormous panels covered with damask fabric, pilasters with ornate capitals, rich Edwardian colours and Victorian murals. Only the radiator caps and baseboards were real marble, the remainder being faux marble moulded from plaster. The mirrors in the hallway were not added until 1935.

The lower theatre was named Loew's Yonge Street Theatre and opened on December 15, 1913. For its inauguration, celebrities arrived from New York, including Marcus Loew, architect Thomas Lamb and Irving Berlin, who introduced a new song for the occasion. The vaudeville team of Weber and Fields was featured. This theatre was the larger of the two auditoriums, seating 2,149 patrons. It featured gilded plaster ornamentations, faux marble finishes and damask wall fabrics. It possessed reinforced concrete floors covered with wood. The lobby and washroom areas were limited, as patrons arrived continuously, entering and departing the theatre at their own convenience. There was no need for a large lobby, as there were no intermissions, only continuous performances.

On February 16, 1914, the upper theatre opened. Named the Winter Garden, it was seven storeys above Loew's Yonge Street Theatre. It was accessed by a grand staircase or by entering one of three elevators. The upper auditorium seated 1,410 persons. The concrete roof of the auditorium was decorated with real beech leaves and cotton blossoms, dipped in preservatives. The ceiling looked like a rooftop garden, and the walls contained hand-painted scenes of gardens. The support columns resembled tree trunks. The sides of the auditorium were painted to appear as if they were garden walls. The ceiling and box-seats were decorated with lanterns.

Both theatres featured the same shows, which typically consisted of eight to ten vaudeville acts, interspersed with a silent movie and a newsreel. The downstairs theatre was nicknamed the Grind House, as it "ground out" continuous shows that commenced daily at 11:00 a.m. The Winter Garden offered reserved seating only, at a cost of twenty-five or fifty cents, and only one performance per evening. In the downstairs theatre, tickets were ten and twenty-five cents. By comparison, a ticket at the Royal Alexandra Theatre was two dollars in this era. With the opening of these two theatres, with their increased prices, the nickelodeon became a thing of the past. Within two years, almost all the theatres throughout the city had raised their prices.

Vaudeville remained popular throughout the 1920s, interspersed with films. However, by the end of the decade, movies had become the most sought-after means of entertainment. In 1928, after fifteen years in operation, the Winter Garden closed. On December 19, 1929, Loew's Yonge Street Theatre screened its first talking picture: *His First Glorious Night*, starring John Gilbert. The advertising for the film stated, "You've seen him make love, now hear him in his greatest romance." The movie also starred Hedda Hopper and was directed by Lionel Barrymore.

In the years ahead, such famous films as *Gone with the Wind* and *The Wizard of Oz* had their Toronto premieres at the theatre. During the screening of *Gone with the Wind*, small coin-operated machines were installed on the backs of the seats. Patrons inserted ten cents and turned the knob, and candy dropped from the slot. They were miniature versions of the bubble gum machines that were popular during the 1940s and 1950s.

In 1960, the theatre was converted to "Cinerama," which required three projectors. To accommodate the expansive, curved screen, the opera boxes and the proscenium arch were removed. This greatly diminished the appearance of the theatre's auditorium.

In 1974, a report stated that the seating capacity of the theatre was 1,700. In 1978, its name was changed to the Elgin. It was open from noon until midnight and showed third-rate movies. However, as the theatre deteriorated, it featured soft-porn movies. The last film it screened was in 1981, and it was entitled *What the Swedish Butler Saw*. By the standards of today, he did not see very much.

The two theatres were saved from demolition by the Ontario Heritage Foundation. The heating system in the Winter Garden had never been turned off, resulting in the theatre being reasonably well preserved. However,

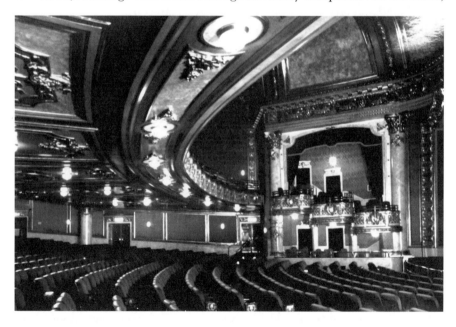

Interior of the Loew's Yonge Street Theatre (the Elgin). *City of Toronto Archives, Series 881, File 53.*

in the projection room of the Elgin, a broken window had allowed birds to enter and nest. The mess they created can easily be imagined.

In 1987, the restoration began under the supervision of Mandel Sprachman. The façade of the original theatre had been altered twice by Thomas Lamb. Sprachman returned it to its original appearance, as conceived by Lamb. To achieve this, the windows facing Yonge Street were uncovered and restored. The box office was also refurbished. It was often referred to as a "gilded bird cage." An underground lounge was added during the restoration.

Seventy-six years after its original opening, the theatre reopened on December 15, 1989. Its former glory can again be experienced today.

SHEA'S HIPPODROME

The next "movie palace" that opened in Toronto was Shea's Hippodrome on Bay Street, north of Queen. In the 1950s, as a teenager, I was fortunate to have attended this theatre. Even today, I can recall sitting in the plush seats of its enormous balcony. The rear rows of the balcony, referred to as the "loges," were reserved for smokers.

Two Ontario-born brothers, Jerry and Michael Shea, were the enterprising businessmen who built the theatre, at a cost of $245,000, an enormous amount of money in 1914. The brothers were later to relocate their residences to Buffalo, New York, where they eventually owned twenty-three theatres in the Buffalo area, as well as the three in Toronto.

When the Hippodrome opened on April 27, 1914, it was the largest vaudeville house in Canada. It contained 3,200 seats, evenly divided between the auditorium and the balcony. The Hippodrome's enamelled white-brick, terra cotta façade dominated Bay Street, with only the west façade of the Old City Hall across from it being more impressive. On the north and south corners of the theatre's east façade were copper-topped towers. The massive marquee soared forty-six feet above the entrance, and its lobby was the largest in the city at that time. To reduce the time people spent in the ticket lines, sales booths were located on both sides of the lobby.

On the evening the Hippodrome opened, the feature film was *Run for Cover*, starring James Cagney. The theatre's auditorium contained intricate plaster mouldings that were painted ivory and gold. The walls and ceiling were decorated in gold and grey. The ceiling contained huge

panels that created a massive dome. The twelve opera boxes had polished brass railings.

When vaudeville entertainers stepped onto the stage at the Hippodrome, they performed in front of a full-sized orchestra pit. Stars included Jack Benny, George Burns and Gracie Allen, Edgar Bergen, Gracie Fields, Ethel Barrymore, Will Rogers and Bob Hope. Red Skelton credited his appearance at the theatre with creating the exposure that led to his stardom.

When the day's featured film at Shea's Hippodrome commenced, the lights dimmed and the great red velvet curtains swept open. As a teenager, I witnessed this spectacle many times, and it was an experience that I never forgot. The screen was so wide that I felt that I was gazing at a 180-degree view of a landscape or street scene. In the close-up shots of the movie stars, the size of the picture created an intimacy that I never experienced again until the introduction of Cinerama and IMAX. The latter technology was pioneered in Toronto.

In 1924, Shea's Hippodrome presented a new marvel: the "phonofilm," which combined the media of radio and moving pictures to create a "talkie." People heard Eddie Cantor sing, accompanied by a symphony orchestra,

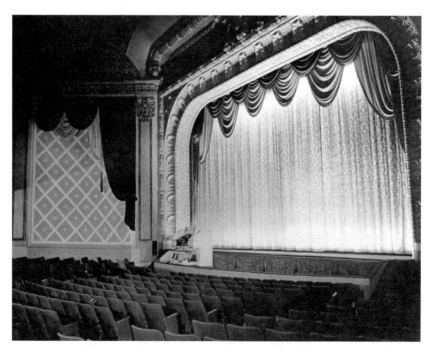

The auditorium and stage of Shea's Hippodrome. *Ontario Archives, RG 56-11-0-325.*

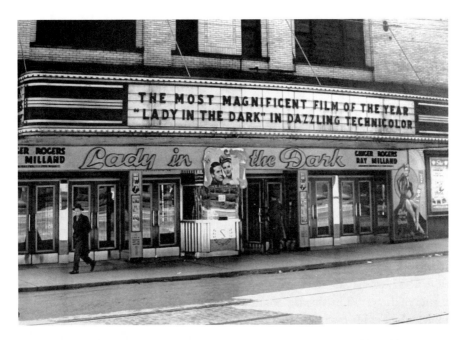

The marquee and entrance of Shea's Hippodrome Theatre, circa 1945. *City of Toronto Archives, Fonds 251, Series 1278, File 153.*

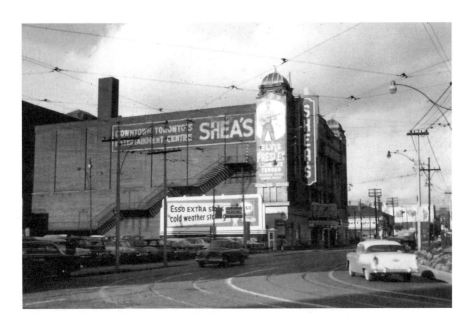

Shea's Hippodrome, the view gazing north on Bay Street in 1959.

with the sound and pictures fully synchronized. Within a week of the opening, my father and his girlfriend, Mary, attended the theatre and were thrilled by the talking, singing characters on the silver screen.

The word *hippodrome* is a Greek word that referred to the enormous oval stadiums where they held chariot and horse races in ancient times. Perhaps the most famous of these was the Hippodrome in Constantinople (Istanbul). Its outline can be viewed today in the modern city, located outside the famous Blue Mosque. Sometimes the word *hippodrome* was added to the names of places that were far from grand in an attempt to add prestige to the venues. In the case of Shea's Hippodrome on Bay Street, the word was entirely appropriate.

In 1926, the Hippodrome was renovated. A Wurlitzer organ was installed, at a cost of $50,000, and the famous organist Roland Todd was hired to perform on the grand instrument.

In 1957, as the attendance of movie theatres began to lag, they demolished the great theatre. The theatre's organ was sold for less than $500 and relocated to Maple Leaf Gardens. Today, it is in Casa Loma. The site of Shea's Hippodrome is now a part of Nathan Philips Square in front of city hall.

ALLEN (TIVOLI)

The magnificent Allen Theatre, another of Toronto's "movie palaces," was located at 17 Richmond Street East, on the southwest corner at Victoria Street. It opened on November 10, 1917, a dismal month in the Toronto calendar. It was a dismal year as well, as the First World War was raging in Europe. Because of the depressing times, the theatre fulfilled a need, since people badly required a distraction from the distressing news from the war front. It was rare to find a family that had not been scarred in some way by the war, as everyone had either a relative, neighbour or friend who was serving in the military.

People entered the Allen through a grand lobby that led to a spacious foyer. Opposite it was an attractive lounge, referred to as a "rendezvous area." Carpeted sloping ramps on either side of the foyer led to the auditorium, which was a staggering size. The Allen was the first theatre in Toronto that departed from the traditional format of an auditorium and balcony. Instead, it possessed a single sloping floor that began at the stage and ascended to the rear wall. Today, it would be referred to as stadium seating.

The architect of the 13,500-square-foot space, which contained 1,553 plush seats, was C. Howard Crane. He also designed the Allen's Danforth and the Bloor Theatre. The *Telegram* newspaper once referred to the theatre as "the wonder of the moment." During the years of silent films, Luigi Romanelli's orchestral often provided the music at the theatre. He also performed at the King Edward Hotel and throughout the years played twenty-seven organ concerts in Varsity Arena, the city's main sports arena at that time.

As was customary with theatres during the early decades of the twentieth century, shops were built along the side of the theatre facing the street. The rent from these shops helped offset the expenses of the theatre. For the Allen Theatre, six small stores were on Richmond Street East and one on Victoria Street. They were included in the building without any loss of seating in the interior of the theatre.

The Allen was constructed in the Adams style, highly decorative but light and airy. It was originally designed for vaudeville and plays, so it contained dressing rooms for the actors. However, it was easily converted to permit the screening of films. The interior did not contain any columns, as there was no balcony. The lighting in the entrance ramp was diffused, pointing toward the floor and thus allowing patrons to find their way in the dark without any disturbing light entering the auditorium. The theatre was also well known for its comfortable seating, wide aisles and well-spaced exits.

In 1923, the name of the theatre was changed to the Tivoli, licensed to Tivoli Theatre of Toronto Ltd. The name was derived from a town near Rome, a famous summer resort with fountains and the Villa d'Este, with its magnificent gardens. The name has been copied the world over and is synonymous with entertainment. Copenhagen's Tivoli Gardens is perhaps the most famous of the venues.

In 1927, the theatre featured the film *The Somme*, about the bloody battle during the First World War. Taxis had carried the French troops to the battlefield. For the opening of the film, the theatre hired sufficient taxi cabs to create long lines of taxis along Richmond Street, near the theatre, with large signs on them advertising the film. In 1938, water-washed air conditioning was installed. In 1946, an acrid odour was detected in the men's room of the Tivoli, and when people's eyes began to water, the fire department was called. A burning cigarette had been left on a plastic toilet seat. The theatre was emptied, but an hour later, the crowds were allowed to return.

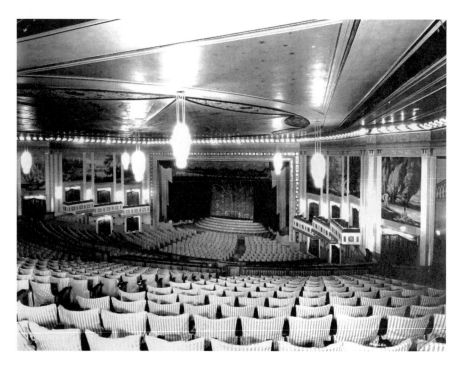

View of the slanting floor from the rear of the Tivoli Theatre, circa 1930. *City of Toronto Archives, Fonds 251, Series 1278, File 160.*

A candy bar was installed in the theatre in 1947. It sold chocolate bars for six cents, despite a recent increase in price of two cents. However, it applied only to children. It created excellent public relations for the theatre.

In October 1948, during the run of the film *Life with Father*, starring Elizabeth Taylor, William Powell and Irene Dunne, it was reported that 33,352 people viewed the movie, of which 1,365 were children. Someone wrote a letter to the editor of the *Telegram* newspaper objecting to the suitability of such a movie being viewed by minors. The writer of the letter felt that the humour was "too rollicking." The manager of the theatre replied that the children had been accompanied by their parents and that elderly ladies and churchmen had attended the screenings, none of whom had complained. The matter was closed. "Toronto the Good" survived another year without any serious defilement.

The theatre was closed in 1965 and was soon demolished.

I remember this great movie house vividly, as it is where I saw the musical *Oklahoma!*, starring Gordon MacRae, Shirley Jones, Gene Nelson and Rod

Steiger. When the film opened at the Tivoli in 1955, it was my first time attending the theatre and the first time I had viewed a widescreen movie in Todd-AO. It was the Tivoli that introduced Todd-AO to Toronto. In 1956, I saw *Around the World in 80 Days* in Todd-AO, and I can still recall the fantastic scenes captured by the camera as it scanned the landscape from the balloon as it soared across the sky. To view this film on a TV screen or mobile device should be against the law. I hope that the Bell Lightbox (TIFF) offers this film soon, as I'd love to see it again on the big screen and hear the music from the soundtrack on its great sound system.

PANTAGES (IMPERIAL, IMPERIAL SIX, CANON, ED MIRVISH)

During the 1950s, I worked as a parceling boy at the Dominion Store on Eglinton Avenue, west of Avenue Road. This statement truly identifies me as "mature," as not only has the name "Dominion Store" been put out to pasture, but supermarkets also no longer hire teenagers to parcel the customers' groceries. Each Saturday evening, after the store closed at 6:00 p.m., a friend and I headed downtown to attend a movie. One of our favourite theatres was the Imperial at 263 Yonge Street, a short distance south of Dundas Street.

At this time, it was not the grand, gold-embossed, pristine theatre that patrons attend today to view the live stage productions produced by David Mirvish. The Imperial was tarnished and somewhat shabby. The ornate plaster trim, gold leaf and faux marble columns from its former days of glory were darkened by the passage of time. We were not aware of the magnificent ceiling decorations in the theatre since the auditorium was darkened whenever we entered it.

During the 1950s, my friend and I were attracted to the Imperial because it featured the most recently released films, and due to the theatre's enormous size, good seats were readily available. We preferred to sit in the balcony, as it was huge and offered a superb view of the screen, one of the largest in the city. The films that I remember the most at the Imperial were those that starred Dean Martin and Jerry Lewis, such as *Scared Stiff* and *The Caddy*, both released in 1953. Being teenagers, we found their zany antics endlessly funny. Two other films that remain vivid in my memory from attending the Imperial are *The Great Caruso* in 1951 and *The Student Prince* in 1954, with both movies featuring the voice of Mario Lanza.

When the theatre opened on August 27, 1920, it was named the Pantages. An ad in the *Toronto Star* listed the opening program:

Doors open at 7 p.m.
Promenade Concert 8 p.m.
Singing of "God Save the King"
Address—Mayor Tommy Church
"Pantages Pictorial Revue."

On August 28, 1920, the following day, the *Mail and Empire* newspaper reported that Charlie Chaplin and Mildred Harris had been present for the opening. The reporter wrote that the Pantages, with its 3,373 seats, was the largest theatre in the British Empire and that it possessed outstanding stage decorations and drop sets with gorgeous colours, including novel background sets for vaudeville acts.

Shortly after the theatre opened, a cantankerous parrot that was blind in one eye was placed in a cage on the mezzanine level of the theatre. It cracked sunflower seeds and squawked at children who tried to poke or steal it. The parrot died in 1941 and was not replaced. During the 1920s, shows ran continuously from 12:00 p.m. until 11:00 p.m., the price of matinees being twenty-five cents; after 5:00 p.m., it increased to forty-five cents. All prices included the abusive antics of the parrot. Patrons arrived at the theatre when it was convenient—not like today, when they enter at the beginning of the film. Because people were arriving and exiting regularly, there was no need for a large lobby.

The main (west) entrance of the Pantages was on Yonge Street, and the east doors were at 244 Victoria Street. Similar to Loew's Yonge Street Theatre (today's Elgin), due to expensive property prices on Toronto's main street, the theatre's auditorium was behind Yonge Street, facing Victoria Street, where land prices were cheaper. However, it was important to have an entrance on Yonge Street, as it was the main street of the city. Assembling the land for the Pantages was complicated because the site had three different owners. However, through a complex set of leases and purchases, the land was finally acquired. The separate ownerships of the land were to haunt the title holders of the theatre in the decades ahead.

The theatre was designed by architect Thomas W. Lamb. Born in Scotland, he immigrated to New York City as a child and had a distinguished career in his adopted city, where he designed forty-eight theatres. He was also the architect of the Boston Opera House, which remains in use today.

In Toronto, he designed the Loew's Yonge Street/Winter Garden complex, as well as the Pantages. One of his trademark features was to attach white- or cream-coloured terra-cotta tiles to the façades of his theatres. These tiles have disappeared from the Yonge Street façade of the theatre of today, the result of the many alterations throughout the decades. However, they remain on its east façade on Victoria Street.

In 1930, the name of the Pantages was changed to the Imperial, under the ownership of Famous Players. On May 29, 1931, Duke Ellington and the Cotton Club Orchestra had their debut at the Imperial. In March 1933, George Raft, who was thirty years old at the time, visited the theatre from New York and made a personal appearance.

While a movie starring Gregory Peck was playing at the Imperial on March 6, 1950, an usher was delivering $1,500 in cash from the box office to the main office inside the theatre and was held up at gunpoint. The robber escaped among the crowds on the street and was never apprehended.

In 1972, following a nine-month run of *The Godfather*, the theatre closed for renovations. When it reopened the following year, the magnificent theatre had been divided into six separate auditoriums and renamed the Imperial Six. It was designed by Mandel Sprachman.

Garth Drabinsky, the CEO of Cineplex Odeon, purchased the property in 1986. He reopened the theatre on December 12, 1987, and continued to screen films for a brief period. Fortunately, he realized the potential of the property as a live theatre and dreamed of restoring it to its former grand status. However, the complicated landownership issues from the 1920s caused many problems. These were eventually overcome, and Drabinsky proceeded with his plans. The last movie shown before it closed for restoration was *Die Hard*, starring Bruce Willis.

Under Drabinsky's supervision, the theatre blossomed again. The seating capacity was reduced from 3,373 to 2,200. The soot and grime were removed, as were the many layers of paint that had obscured its original beauty. Backstage areas were improved, and computerized stage lighting was installed, along with a new sound system.

When it reopened in 1989, with Andrew Lloyd Weber's Musical *Phantom of the Opera*, theatregoers were once more able to enjoy the opulence of the original Pantages. The musical was to remain on stage for more than ten years, attracting crowds from all over Ontario and the United States. I saw *Phantom* three times during its long run. However, the first time was the most memorable, since it was when I first glimpsed the theatre after its restoration. I thought of the stories my father had told me about his visit to the theatre in

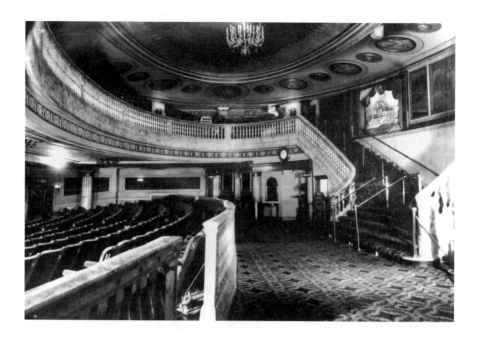

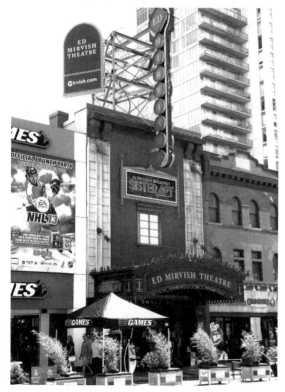

Above: The rear of the auditorium and the grand staircase of the Pantages Theatre. *City of Toronto Archives, Series 881, File 146, Item 1.*

Left: The theatre in the summer of 2012, after it became the Ed Mirvish Theatre. There was a pedestrian mall on Yonge Street.

June 1921 and realized that his descriptions of the theatre's grandness had indeed been accurate. Even today, when I attend the theatre, at intermission I walk down an aisle toward the stage area, where I can gaze upward at the vaulted ceiling in all its glory.

After Garth Drabinsky's theatrical empire collapsed, the Pantages was purchased by Clear Channel Entertainment and became the Canon Theatre. Eventually, David Mirvish bought the theatre and renamed it the Ed Mirvish Theatre on December 6, 2011. Although many of the great venues from North America's golden age of theatre-building have been demolished, the imperial empress of Canadian Theatres—the Ed Mirvish—continues to offer live performances, reminding us of the days when such structures were referred to as movie palaces. There could never be a more fitting tribute to one of the city's most generous benefactors—Ed Mirvish, the "King of Retail"—than placing his name on this great theatre.

LOEW'S UPTOWN

Loew's Uptown at 764 Yonge Street was another of Toronto's great movie palaces. It was named the Uptown to distinguish it from the downtown theatre near Queen Street. The Uptown Theatre opened in September 1920 as a vaudeville and movie house. Marcus Loew, the financier who became a movie magnate, constructed the theatre. He also owned Loew's Yonge Street (Elgin) and the Winter Garden Theatres, which had opened in 1913–14. The architect for the Uptown was Thomas W. Lamb, who also designed Loew's Yonge Street (Elgin) and the Pantages (Ed Mirvish) Theatres.

From the early days of movie theatres until the early 1960s, as previously mentioned, films were shown continuously throughout the day, with patrons leaving and entering the theatre whenever they wished. As a result, large lobbies were unnecessary. The lobby at Loew's Uptown was even smaller than that of the Pantages. However, similar to the Pantages, the theatre's frontage on Yonge Street was narrow due to the expensive real estate prices on the city's main street. To compensate, a grand hallway led from the street to the theatre auditorium, which was behind the shops that fronted on Yonge. During the 1950s and 1960s, I climbed the grand staircase to reach the interior of the theatre many times. I always marvelled at its rich ornamentation.

In 1920, Marcus Loew came to Toronto to attend the opening of his magnificent new theatre. On the morning of the event, when he arrived from New York, Mayor Tommy Church met him at Union Station and escorted him to the King Edward Hotel. The opening-night film was D.W. Griffith's *The Love Flower*, released that year by United Artists. The orchestra of Frank Arundel provided the music to accompany the silent film. The greatest number of film stars ever to appear in the city to that date were assembled for the opening. They included Bert Lytell, a resident of Toronto, who was a boxer prior to becoming a movie star. Other stars at the opening were Delores Cassinelli and Carol Dempster, the latter one of the stars of *The Love Flower*.

The 2,800-seat theatre was the height of luxury, even containing a Japanese temple garden. The theatre was decorated in colours of rose, grey and gold, tastefully blended to create an atmosphere that some referred to as restrained elegance. Concealed diffused lighting illuminated the auditorium. Intricately detailed plasterwork, decorative arches and classical columns ornamented the auditorium, lobby and entranceway. On the dome above the auditorium was an enormous design similar to the one that today graces the ceiling of the Ed Mirvish (Pantages) Theatre.

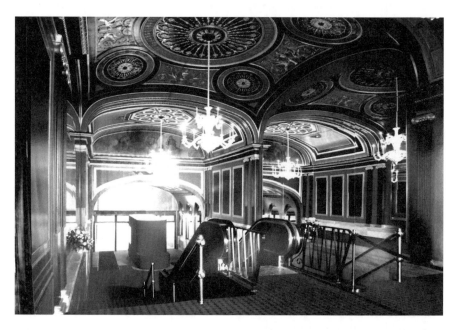

The entrance of Loew's Uptown Theatre, viewed from the interior. *City of Toronto Archives, Series 881, File 241.*

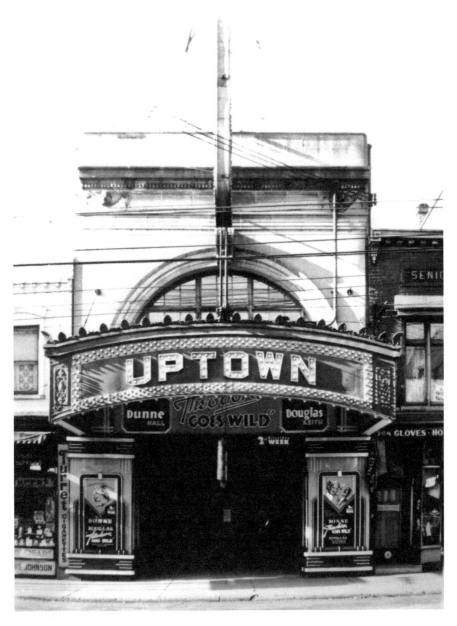

Loew's Uptown Theatre in 1936. *City of Toronto Archives, Series 881, File 350.*

A fire in the 1960s damaged the Uptown Theatre. When it was restored, some of the original plasterwork was replaced with smooth plaster rather than attempting to duplicate the 1920s designs. However, the large medallion-like design on the dome, above the auditorium, was maintained. Some of the damaged areas were covered with drapery rather than paying the expense of restoration.

In 1969, Nat Taylor owned the theatre. He closed it on September 5 of that year to convert it into five separate cinemas. The Uptown 1, 2 and 3 screened first-run movies, and the Backstage 4 and 5 featured art films. The entrance to the backstage theatres was on

The Uptown Theatre, circa 1993, after it had been converted to the Uptown 5. *City of Toronto Archives, Ken Webster Collection, Fonds 251, Series 1278, File 165.*

Balmuto Street, behind the theatre, to the west. The Uptown 5 was one of the world's first multiscreen complexes. The architects Mandel Sprachman and Marvin Giller were hired for the redesign. In 1970, Nat Taylor sold the theatre to 20th Century Theatres, which had no connection to the famous studio of the same name. It was Nat Taylor who later entered a partnership with Garth Drabinisky to form Cineplex Odeon Corporation.

In the first decade of the twenty-first century, the city demanded the Uptown be updated to include wheelchair access. A court case ensued, and the theatre lost. The cost would have been $700,000 for the alterations, and in a time of dwindling theatre attendance, the funds could not be justified. Sadly, the theatre was sold, and it closed on September 14, 2003, following a showing of the TIFF film *Undead*. A forty-eight-storey, 284-suite condo was constructed on the site.

PART III

SMALLER THEATRES
IN THE PRE-1920s AND 1920s

OAKWOOD

The Oakwood Theatre opened in 1917 in the suburban community of Earlscourt, to the northwest of the downtown area. It was located on Oakwood Avenue, a short distance north of St. Clair. When it opened, its only rival in the neighbourhood was the much smaller Royal George Theatre, west of Dufferin Street. The Oakwood Theatre was a project of the developer James Crang Jr. In his honour, the street one block to the west of Oakwood Avenue was named Crang Avenue.

In 1924, after the Rogers Road streetcar line was inaugurated, its southern loop at St. Clair was constructed around the theatre. Eventually, the Oakwood streetcar used the same loop. The Oakwood was then situated at a transportation hub. Many people were able to travel to the theatre on either of the two streetcar lines.

A description of the theatre in the files of the Toronto Reference Library notes that the Oakwood's auditorium had large crystal chandeliers but no balcony. The façade facing Oakwood Avenue was unadorned, with terracotta tiles on the slanted roof. These tiles (Mediterranean/California in style) were quite popular throughout the 1920s. The apartment buildings on the south side of St. Clair, immediately east of Oakwood Avenue, possess the same type of tiles and can be seen today (2014).

The Oakwood eventually became part of the Famous Players chain. While downtown theatres screened the latest Hollywood films, the Oakwood showed

The Oakwood Theatre, November 19, 1924. *City of Toronto Archives, Series 881, File 350.*

movies that appealed to the British immigrants who lived in the surrounding area. The theatre was demolished in 1962, and there is now an apartment building on the site, with the postal address of 161 Oakwood Avenue.

I remember the Oakwood Theatre well, as I attended it many times as a teenager. During the evenings, between film features, there was an intermission, when many patrons went outside to enjoy cigarettes. A friend and I sometimes mingled with the crowd and snuck into the theatre to view the second film of the evening without paying admission. Somehow we managed to live with our guilt and enjoy the film.

Broadway (Globe, Roxy)

The Broadway Theatre was located at 75 Queen Street West. When it opened in 1919, to the east of the theatre was the low-budget White Hotel, one of several economy hotels along the strip where the theatre was situated. When I was a teenager in the 1950s, along with the famous theatre the Casino, five doors to the west, the Broadway was one of the theatres that I remember was frowned on by polite society. This was because it featured burlesque and "girlie shows" as well as films.

I feel that perhaps my teenage years were far less eventful than others, as I was never inside the Broadway. However, I can recall it quite clearly, as I often attended Shea's Hippodrome, a short distance away. The reason I never darkened the doors of the Broadway was that when I was a teenager in the 1950s, it screened movies that had been released five or six years earlier, and I had already seen them in our neighbourhood theatres. As well, I was too young to purchase a ticket to a girlie show. As a result, my innocence remained intact for a few more years.

The Broadway was originally named the Globe Theatre. With almost five hundred seats, it offered vaudeville and movies. Around the year 1933, it changed its name to the Roxy, and it was then that it added girlie shows to its standard fare of vaudeville and B-movies. In February of that same year, two eighteen-year-old youths decided to get married on the stage of the theatre. The event attracted a large audience, as the ceremony was advertised as part of the show. When the time arrived for the ceremony, on the stage was a Baptist minister, the bride adorned in her bridal gown and the groom beside her in his tuxedo. As the jazz band in the orchestra pit readied to play the wedding march, the police crashed into the theatre. The parents had summonsed them, as they claimed that the teenagers were

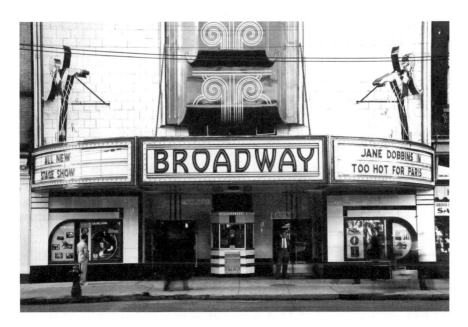

The Broadway Theatre. *City of Toronto Archives, Fonds 124, Series 1143, File 140.*

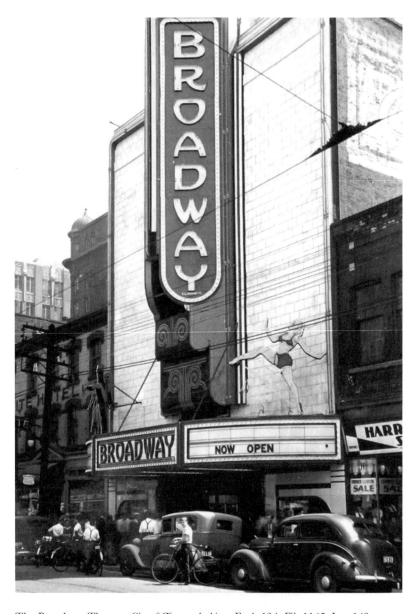

The Broadway Theatre. *City of Toronto Archives, Fonds 124, File 1145, Item 142.*

underage. However, the marriage was performed the following afternoon, after the participants proved that they were of sufficient age. The event gave the theatre much free publicity, although many people in Toronto frowned on the entire affair.

In 1935, the manager of the theatre was found murdered in his office, shot twice in the head and sprawled in a pool of blood. It was found that $378 was missing from the safe, but the police did not believe that robbery was the motive. A friend of the victim had talked with the manager two days prior to the killing and told police that his friend had appeared worried. He had enquired, "What's the matter? Business no good?" But he received no reply. The manager's son-in-law stated at the inquest that there were problems among the actors in the burlesque show and that several of them had threatened to quit. Still, he knew no motive for the murder. The crime was never solved.

In 1937, the name of the theatre was changed to the Broadway, which conjured images of the fashionable theatre district in New York City. However, similar to the Casino, the Broadway Theatre continued to be viewed as a "strip joint."

When the city expropriated the land on the north side of Queen Street to build the new city hall, civic officials decided that the row of buildings on the south side of Queen Street was not compatible with the image they wished to create for the city. In 1965, the buildings in the block where the Broadway was located were expropriated and demolished.

The Broadway disappeared. Only a few memories and photographs of this infamous theatre remain.

CARLTON ON PARLIAMENT STREET

The Carlton Theatre is not to be confused with the much larger Odeon Carlton, located on Carlton Street near Yonge. The Carlton Theatre was located at 509 Parliament Street, on the east side of the street. It was a short distance north of Carlton Street, near Aberdeen Street, in the area that today is referred to as Cabbagetown.

When the Carlton Theatre opened in 1919, it was a modest-sized neighbourhood theatre, possessing seven hundred seats. The theatre had a red-brick façade, with few ornamentations and a plain cornice. In the 1940s, the theatre became part of the B&F chain. This company was formed in 1921 through a business partnership of Samuel Bloom and Samuel Fine. At its peak, the company operated twenty-one theatres. In 1927, it became associated with Famous Players Corporation. B&F prospered until the 1950s, when the effects of television and the city's demographic changes diminished

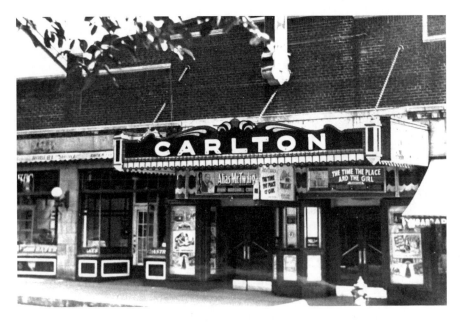

The Carlton Theatre on Parliament Street. *Ontario Archives, RG 56-11-0-276.*

the appeal of neighbourhood movie houses. At its height, B&F operated such theatres as the Donlands, Century and the Vaughan. It was B&F that pioneered the concept of screening double-bill (two movies) programs for a single price. This allowed the smaller theatres to compete with the larger downtown theatres that showed first-run films. The first time it attempted this idea was in 1923 at the Christie Theatre on St. Clair, located between Wychwood Avenue and Christie Street.

In November 1948, a candy bar was installed in the Carlton Theatre. During the 1950s, during intermissions, a fifteen-year-old boy played 78rpm records of the latest hit-parade songs from the projection booth. This proved highly popular with teenagers. In January 1952, the matron who patrolled the aisles during screenings discovered children sitting on the floor near the stage, even though there were many empty seats. They were in a group that wanted to sit together. Fearing that there would be trouble, they were all ejected from the theatre. In December 1952, the theatre advertised a "New Year's Eve Midnight Show" and called it "The Frolics of 53—Girls, Gags, Comedy."

The Carlton Theatre closed its doors on Saturday, September 25, 1954. The building became studio space for the CBC. After the CBC vacated the premises, it was occupied by the Children's Dance Theatre. It remains in the building today (2014).

VICTORY ON YONGE STREET
(EMBASSY, ASTOR, SHOWCASE, FEDERAL, NEW YORKER, PANASONIC)

The theatre that exists today on the site at 651 Yonge Street was originally the site of a four-storey residence, built in 1911 in the Second Empire style, with a Mansard roof containing windows with ornate surrounds. In 1919, the house was gutted and converted into a theatre, named the Victory. With the successful end of the First World War in 1918, the name of the theatre was particularly appropriate. However, in 1934 it was changed to the Embassy. During the years ahead, the theatre's name changed several times, becoming the Astor, Showcase, Festival and New Yorker.

During the 1970s, the theatre was one of the venues for the "Festival of Festivals," which later changed its name to the Toronto International Film Festival (TIFF). On Christmas Day 1978, I saw the film *The Last Emperor*, the story of Tao Wu, the last emperor of China. In 1993, the theatre was renovated and converted from a movie theatre into a venue for live theatre. It was renamed the New Yorker. It premiered the Toronto production of the off-Broadway musical *Forever Plaid*, a revue of the harmonizing male groups

The Astor Theatre, circa 1938. The Panasonic is now located on the site. *Ontario Archives, RG 56-11-0-302.*

Interior of the Astor Theatre, before the building was demolished to build the Panasonic. *Ontario Archives, RG 56-11-0-303.*

popular in the 1950s. The production opened with a spoof version of the song "Love Is a Many Splendid Thing." I remember seeing the show at the New Yorker and having enjoyed it immensely.

During 2004 and 2005, the theatre was demolished, except for the façade. A modern theatre was constructed on the site of the residence built in 1911. In June 2005, the theatre was purchased by Live Nation, and in 2008, it was bought by David Mirvish. It is presently named the Panasonic, its early twentieth-century façade mostly obscured by metal webbing.

ALLEN'S DANFORTH (CENTURY, TITANIA, MUSIC HALL)

The theatre that today is the Danforth Music Hall, at 147 Danforth, is located on the south side of the street, a short distance east of Broadview Avenue. It was originally the Allen's Danforth.

The Allen brothers, two enterprising young businessmen, opened the theatre in 1919. They had arrived in Toronto in 1915, having acquired considerable experience in building and operating theatres. They opened the Allen Theatre (later renamed the Tivoli) on Richmond Street in 1917.

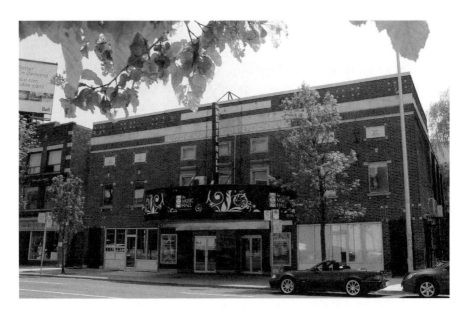

The Danforth Music Hall (formerly the Allen's Danforth Theatre) in 2013.

In 1918, when the Prince Edward Viaduct was completed across the Don Valley, the Danforth area on the east side of the valley became more accessible from the downtown. This was greatly assisted by the extension of streetcar service, continuous from Bloor Street to the Danforth, across the Prince Edward Viaduct. The Allen brothers knew that residential development would expand into the area and decided to be among the first to offer the new form of entertainment—"photo plays."

The historic plaque that today is on the façade of the theatre reveals that when the theatre opened in 1919, it was advertised as "Canada's First Super Photoplay Palace." The records in the Toronto Archives state that the theatre opened as a vaudeville house and screened silent films. It converted to sound films in 1929. The architects were Hynes, Feldman and Watson, who were part of the firm of Howard Crane of Detroit, which designed the Tivoli and the Bloor Theatres. The 1,600-seat Allen's Danforth was taken over by Famous Players in 1923 and was renamed the Century. During the 1970s, the theatre screened Greek films, and it was known as the Titania. In 1978, it was renamed the Music Hall, offering live stage performance. However, a roll-down screen allows it to also show movies.

PARKDALE

One of the features listed on the marquee of the 1927 photo of the Parkdale Theatre is the Laurel and Hardy movie *Chump at Oxford*, released in 1940. This theatre was located at 1605 Queen Street West, on the southwest corner of Queen and Triller Avenue. I was never inside this venerable theatre, but I remember it well. When I was a child in the 1940s, the most anticipated event of the summer was a trip on the streetcar to the fabled playground beside the lake—Sunnyside. We travelled on the Queen Street streetcar, alighting at Roncesvalles. The theatre loomed large near the intersection. As a child, I thought it was a massive structure and longed to be of an age to attend it.

In later years, as a teenager, I went swimming on hot summer nights at Sunnyside Pool and again travelled on the Queen Streetcar to Roncesvalles. I always knew when I had arrived at the stop where I was to disembark when I saw the theatre on the south side of the street.

The Parkdale Theatre opened in the spring of 1920 as part of a chain of theatres operated by the Allen brothers. They also owned the famous Allen Theatre, later renamed the Tivoli, at Adelaide and Victoria Streets. The Allen brothers realized the potential of the Parkdale area for a theatre site, as nearby Sunnyside Amusement Park was under construction on the lakeshore. They gambled that a theatre in the area would draw more than just patrons from the local community. They were correct. When Sunnyside opened in 1922, many Torontonians visited the park beside the lake to escape the heat and humidity of the city's summers. Some attended the Parkdale Theatre before boarding a streetcar to journey home. It is interesting to note that Sunnyside became known as the "Poor Man's Riviera."

In the 1920s, the Parkdale was a considerable distance to the west of the downtown. Designed by Howard Crane, the auditorium of the theatre was situated parallel to Queen Street. Patrons entered it at the northeast corner of the building. It possessed 1,546 seats, with leatherette backs. The auditorium was expansive and richly decorated with Wedgewood-style plaster ornamentations, with circles radiating outward from a central medallion. The theatre was fully fireproof, so it advertised that smoking in the designated section was entirely safe. During the 1950s, the theatre was operated by Famous Players Corporation.

The file on the Parkdale Theatre in the City of Toronto Archives details many happenings within the theatre. On January 13, 1938, the Parkdale screened the film *Said O'Reiley to McNab* without approval from the Ontario Censor Board. This was a serious offense, as in this decade, the government maintained

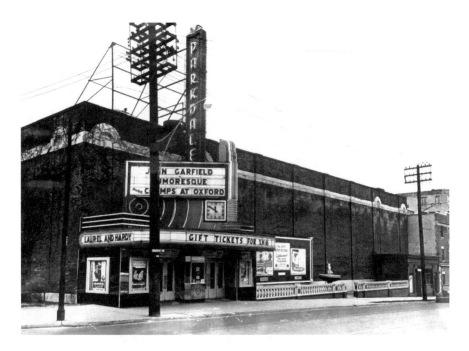

The Parkdale Theatre in 1927. *Ontario Archives, RG 56-11-0-312.*

strict control over the censoring of movies. The matter was resolved when the projectionist produced a letter that granted permission from a Mr. Silverthorne from the board. It should be noted that the theatre did a little censoring of its own. It had a blacklist of more than one hundred youths who were not permitted in the theatre, as they had committed some offense or another on previous visits. As well, teenage girls who attended on their own were not seated near the boys. If they "seat-hopped," they were ejected.

On February 21, 1950, two detectives overpowered a notorious thief named "Baby-Faced Byers," who derived his nickname from the fact that, although he was thirty years old, he looked much younger. When confronted by the detectives, he reached for his gun but failed to draw it in time to prevent his capture. Box office robberies were a constant threat, so most theatres maintained hidden alarm buttons that cashiers could press to alert the management to problems.

A patron complained in October 1953 that smoking was everywhere throughout the theatre, and teenagers were exhibiting deplorable behaviour— kissing, necking and shouting. The person complaining added, "It looked like a passion den for teenagers." When I read this report, I remembered that as teenagers, we referred to drive-in theatres as "passion pits."

On November 5, 1954, the Parkdale Theatre was inspected from 8:30 p.m. until 9:50 p.m. On this occasion, unknown to the inspector, the manager refused entrance to more than fifty teenagers at the box office, thus ensuring that no rowdies were in the theatre. The inspector sat near the front of the auditorium and later reported that everyone was well behaved. He never learned the reason.

In 1955, a woman reported that there was a problem with rats in the Parkside Theatre and that there was water in the basement. The report does not indicate how she knew about the problems in the basement. I suppose it is possible that the women's washroom was located there. However, upon inspection, it was discovered that water was running down a basement wall, its origin being from the building to the west of the theatre. A rain gutter was installed. An inspector later revisited the theatre and said that he had found no rats. A theatre employee said of the woman who had made the complaint, "This woman, in my humble opinion, is crocked."

The Parkdale closed on July 6, 1970, having screened movies longer than most neighbourhood theatres. The building remains in existence today, having been converted into several shops that specialize in antique and secondhand furniture.

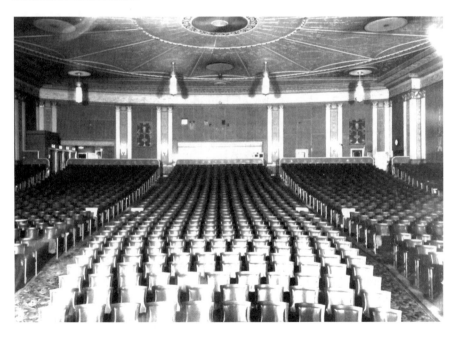

Auditorium of the Parkdale. *Ontario Archives, RG 56-11-0-312.*

ALHAMBRA (BARONET, EVE)

The Alhambra Theatre opened in 1920 as a movie and vaudeville house. It was located at 568 Bloor Street, on the north side of the street, a short distance west of Bathurst Street. Its marquee was impressive, but it did not obscure the excellent architectural detailing of the façade, which contained a large Moorish arch and support pillars that resembled those in the Alhambra Palace in Granada, Spain. Windows facing the street also contained Moorish ornamentation. It was from these features that the theatre derived its name.

On the day of the opening, the price of an orchestra seat was twenty-five cents, balcony fifteen cents and loges and boxes thirty-five cents. There was a 2:00 p.m. show and an evening show that commenced at 7:00 p.m. Both featured a musical review and the film *Back Stage*, starring Fatty Arbuckle, as well as a short play entitled *The Woman Thou Gavest Me*, based on the book by Hall Caine. Then, as was typical of the decade, the performances ended with a rousing rendition of "God Save the King."

An incident in August 1946 garnered the attention of the press. A firebug ignited three separate fires in different locations in the theatre. Fortunately, they were all quickly extinguished, and there was little damage. In 1949, the theatre received a new marquee, and in the auditorium, improved seating was installed. In 1950, the furnace overheated and caught fire, but the theatre was evacuated without any panic. Passes were distributed for patrons to return for another performance.

I am sorry to report that I did not discover any scandals associated with the Alhambra, but in 1954, the manager was warned not to allow the theatre's matron to work in the candy bar. As previously mentioned, matrons were women hired to supervise the theatre during performances to ensure that patrons behaved properly. I shudder to think what sins were committed in the back rows of the theatre when the matron was busy selling confections at the candy bar. Perhaps a wandering hand strayed in the wrong popcorn box.

In 1969, Famous Players Corporation commenced operating the theatre, after renovating it and changing its name to the Baronet. At this time, the box office was relocated to the right-hand side of the entrance, and the stairs to the balcony on the east side of the lobby were removed.

When theatre attendance declined in the 1960s, the Alhambra changed its name to the Eve and showed porno films. By the standards of today, the term "porno" had a different meaning, since most of these

The Alhambra, circa 1935, after the marquee had been altered, obscuring the façade with its Moorish designs. *City of Toronto Archives, Series 880, File 350, Webster Collection, Fonds 251, Series 1278, File 165.*

films could now be shown on primetime television. When the theatre was demolished in the 1980s, the building erected on the site contained a Swiss Chalet Restaurant. After the restaurant closed, various retail establishments occupied the location.

ST. CLAIR

The St. Clair Theatre was at 1154–56 St. Clair Avenue West, near the northeast corner of St. Clair and Dufferin Streets. When it opened, it was in the heart of the shopping district of the suburban community of Earlscourt, an area where many British immigrants resided. It was an era without TV, although radios were becoming more common. Lacking modern home entertainment devices, people gravitated to main streets to "people-watch." In the Earlscourt District, St. Clair Avenue was "the place" to stroll whenever the weather permitted. Young men and women cruised along the avenue in hope of catching the eye of an attractive stranger. Couples wandered along the sidewalk as well, many of them attending the St. Clair Theatre for an evening's entertainment.

The original plans for the St. Clair were drawn up in February 1919 for the Allen chain, and it opened its doors in 1921. The architects were Hynes, Feldman and Watson. Their design was similar to those for the Parkdale Theatre on Queen Street West. The yellow-brick St. Clair Theatre was a large building with considerable frontage on St. Clair Avenue, dominating the city block east of Dufferin Street. It contained 1,137 leatherette seats and a balcony that accommodated a further 419 patrons. Its license was eventually transferred to Famous Players Corporation. In 1950, the theatre was extensively renovated and new seats installed. The number of seats on the main floor was reduced to 1,030 and the balcony to 400.

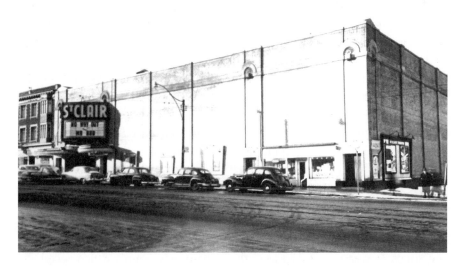

The south façade of the St. Clair Theatre, circa 1947. *Ontario Archives, RG 56-11-0-317.*

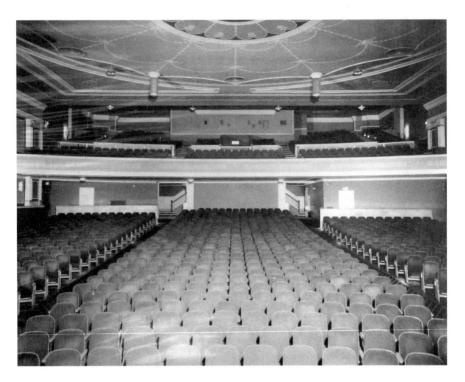

The orchestra and balcony of the St. Clair Theatre, revealing the ornate designs on the ceiling of the auditorium. *Ontario Archives, RG 56-11-0-317.*

On August 14, 1956, a fire broke out at 10:15 p.m. in the backstage area. There was no panic, and the theatre was quickly evacuated. It was discovered that a cigarette in the ushers' dressing room caused the fire. The damage was slight, and the theatre reopened the following day. In the 1960s, because of the decline in attendance and the demographic changes in the district, the theatre was divided into two auditoriums and showed Italian films.

In 1967, a three-year-old child was discovered inside the auditorium. No one ever determined how the youngster entered the theatre. People were scandalized by the incident, as two restricted films were being shown. It seems the authorities were more concerned about the child's morals being corrupted by the films than the fact that a toddler was alone on a busy street. Besides, how much of the content of the films could a three-year-old have understood?

After the theatre closed, because the theatre auditorium was parallel to the street, it was easy to convert the structure to shops, which faced the avenue for easy customer access.

STANDARD (STRAND, VICTORY, GOLDEN HARVEST)

It is difficult to believe that in the Chinatown, on Spadina Avenue, there was once a risqué burlesque theatre that scandalized the city. Toronto's mayor spoke out against one of the "ladies" who appeared on its stage and created so much free publicity for her that he was jokingly referred to as the unofficial head of her fan club.

The theatre was on the northeast corner of Spadina Avenue and Dundas Street West. Today, the yellow-brick building still exists and is an integral part of the street scene. Hundreds of people pass it daily, but few gaze up at the structure. However, some of us who are older retain memories of a theatre when it was famous and infamous.

The first building on the northeast corner of Spadina and Dundas Street was a small frame church where the Methodist New Connection Congregation worshipped. Built in 1871, the church property was later purchased by Dr. Henry H. Moorehead. He demolished the church and constructed an impressive residence, where he lived for more than thirty-five years.

The doctor's house was demolished, and in 1921, an Austrian immigrant named Isadore Axler erected the Standard Theatre on the site. Designed by

The building that was formerly the Victory Theatre. Photo taken during the summer of 2013.

Benjamin Brown, the theatre was built to feature Jewish dramatic productions. Axler financed it by selling shares to the local Yiddish community. In its day, it was one of the finest Yiddish theatres in North America, offering melodramas, comedy and tragedies. A New York touring company performed the classics in the theatre, translating Shakespeare into Yiddish. The theatre was also used for political events. In 1929, the police were called to control a riot that broke out at a meeting to commemorate the death of Lenin.

In 1935, the theatre was renamed the Strand, and it became primarily a movie house, although it continued to offer live theatre and lectures. To celebrate the end of the Second World War in 1945, the name of the theatre was changed to the Victory. It again offered live performances, but this time it also featured burlesque. During its infamous period as one of Toronto's "strip joints," such famous stars as Knackers Knock, I-Need-a Man, Cup Cakes Cassidy and the Bazoom Girl performed on its stage. The theatre was a favourite of university students and Bohemian types, who enjoyed watching tassels twirl as busty gals gyrated and danced to provocative music.

In 1962, two detectives reported that at a performance at the Victory, one of the girls, "after removing all her costume, with the exception of a flesh-coloured G-string and pasties, lay on the floor gyrating and raising her hips and simulating the act of sexual intercourse, while moaning as she was performing. At the conclusion of her act, she lowered her G-string, exposing the pubic hair and a portion of her private person." Charges were laid, and the theatre was fined $100. The manager was fined $50 or five days in jail. However, when the stripper appeared in court, the judge dismissed the charges against her. Perhaps he was a connoisseur who appreciated the refined art of stripping or had been at the performance and enjoyed her talents. Stranger things have happened.

In 1962, the theatre was cited for displaying signs on the street that showed semi-clad girls. The morality squad laid charges, and the theatre agreed to have the girls shown in bathing suits or similar attire.

During the 1970s, the area's demographics slowly changed, and it became a focal point for the Asian community. In 1975, Hang Hing bought the theatre, renovated it and renamed it the Golden Harvest Theatre. Finally, the theatre was closed, and the building was converted for other commercial purposes, including several shops and a bank.

It has been said that the theatre auditorium inside the yellow-brick building remains intact today. Perhaps it is awaiting a revival of this infamous form of entertainment. Burlesque anyone?

PALACE

The magnificent Palace Theatre at 664 Danforth Avenue was a few doors west of the northeast corner of Danforth and Pape. A copy of the opening-night program for the theatre survives in the City of Toronto Archives. It reveals that the theatre opened on February 21, 1924. One of the opening-night features was the silent film *Midsummer Madness* (1921), directed by William Churchill de Mille, the older brother of the famous Cecil B. de Mille. It was a drama starring Jack Holt, Conrad Nagel and Lois Wilson. On the same program was the comedy film *My Goodness* (1921), starring a popular slapstick comedian of the 1920s, Louise Fazenda. The music for the silent films was provided by the Ladies Orchestra, conducted by Miss Marjorie Stevens.

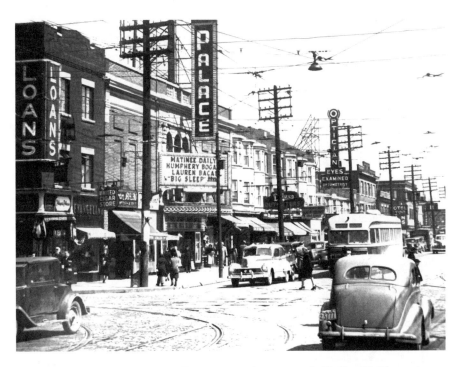

The Palace Theatre in April 1947. The movie on the marquee is *Big Sleep* (1946), starring the famous duo of Humphrey Bogart and Lauren Bacall. The view looks east along the Danforth, from the southwest corner at Pape. The streetcar is a PCC car, first introduced to the city in 1938. Two of the streetcars from Toronto's fleet of PCC cars remain in existence today and can be seen on major routes during the summer tourist season. The majority of the remainder was sold to Cairo, Egypt. *City of Toronto Archives, G&M Collection, Fonds 1266, Item 114209.*

The 1,575-seat theatre had no balcony. The floor sloped from the stage to the back wall, providing excellent sightlines from all the rows. The Tivoli Theatre on Richmond Street had been the first theatre in Toronto to offer this type of seating. The loges section at the rear of the Palace was the designated smoking area, and tickets for this section cost more. However, the seats were plusher than in the other sections of the theatre. The ceiling of the theatre had Wedgewood-style designs with concentric circles and a chandelier in the centre, similar to the Parkdale Theatre at Queen and Roncesvalles.

The theatre's lobby contained extravagant gold ornamentations. Furniture in the lobby was silver-grey. Marble staircases on the east and west sides gave access to the washrooms on the second floor. The east–west aligned auditorium was parallel to the street, which allowed shops to be built into the theatre's façade that faced Queen Street without the loss of any interior space.

In 1937, all matinees at the Palace were twenty-five cents. In the evenings, from 6:30 p.m. until 7:30 p.m., tickets were the same price. However, from 7:30 p.m. until closing, they were thirty-two cents. It cost forty cents to sit in the loges. Even then, smoking was an expensive habit. The reduced prices at the early evening hours were an attempt to fill seats at a time that was generally sparsely attended. All these prices included the Ontario Amusement Tax.

I was never inside the Palace Theatre, but I remember its impressive marquee and façade as I often passed by it on the Bloor streetcars when travelling along the Danforth.

Unfortunately, the theatre closed in 1987, having remained open longer than most neighbourhood theatres.

BEDFORD (PARK)

In the nineteenth century, north Yonge Street was a farming community remote from the city. On market days, it was a favourite stopover for farmers hauling their produce to Toronto's St. Lawrence Market. However, as the twentieth century progressed, it developed as a middle-class residential community, with mostly semi-detached houses. In the 1920s, it possessed sufficient population to support a movie theatre, resulting in the Bedford Theatre being opened in 1926.

The Bedford was located at 3291 Yonge Street, on the east side of the street, near Glenforest Road. It was designed by Murray Brown, the architect of the Belsize Theatre on Mount Pleasant Avenue. The Belsize Theatre survives to this day, although it has been renamed the Regent. The Bedford Theatre's façade was in the Mediterranean style, with a white stucco covering and terra-cotta tiles on the slanted roof. The original façade was obscured when the large marquee was added to the front of the building.

In the early 1940s, the name of the theatre was changed to the Park, and it was operated by Famous Players Corporation. In 1948, the management of the Bedford was chastised by the authorities for holding a Thursday afternoon matinee without proper authorization. The following year, the theatre again found itself in trouble with the authorities. It opened on a Sunday afternoon to allow actors to audition for an amateur production. This was against the law since Sunday openings were forbidden. The theatre argued that only twenty people were in the theatre at the time and that no admission charge had been paid by those who attended. The matter was dropped.

On January 23, 1948, the theatre was robbed at gunpoint, but the thief was apprehended with fifteen minutes. The police arrested him in another

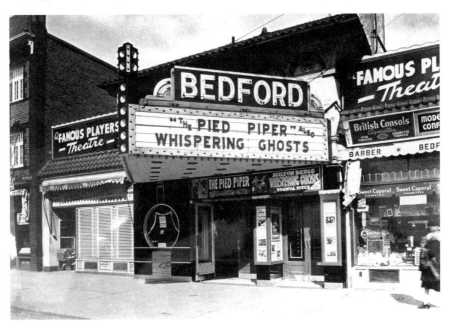

The Bedford Theatre in 1942, before it was renamed the Park. *Ontario Archives, RG 56-1101-366.*

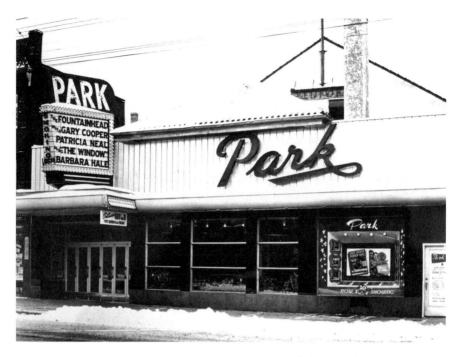

The Bedford Theatre, circa 1949, when it was named the Park. *Ontario Archives, RG 56-11-0-286.*

theatre, where he had attempted to hide in the darkness among the patrons. The same year, the theatre was extensively renovated, and in June of the following year, air conditioning was installed.

In 1951, the theatre again found itself in trouble with the law as it allowed its Saturday evening screenings to extend past midnight. On one occasion, it was discovered that a film had ended at 12:45 a.m., a major offence. It seems that the theatre possessed a propensity for offending provincial regulations.

After the theatre ceased screening films, its interior was gutted and redesigned for other commercial entities, but the side walls and façade of the theatre remain.

HUDSON (MOUNT PLEASANT)

The Mount Pleasant Theatre is another one of Toronto's movie houses that has survived into the modern era. When it opened in 1926, it was named the Hudson. At the time, the northern part of Toronto that centred on Yonge

Street and Mount Pleasant Avenue, near Eglinton, was undergoing a residential building boom. Located at 675 Mount Pleasant Avenue, the Hudson was on the east side of the street, between Soudan and Hillsdale Avenues. Similar to other suburban theatres, it did not attempt to compete with the larger downtown venues by offering first-run films but instead screened double-bills. Shops on either side of its entrance provided extra income to offset the expenses of operating the theatre.

The Mount Pleasant Theatre in 2013.

The architect of the Hudson was La Marque, and the builder was R. Luxton. Its auditorium had a wooden/macadam floor and two aisles but no balcony. It contained 456 seats, with wooden backs and leatherette seats. The air conditioning system was water-washed air, typical of theatres in that decade. However, a more advanced system of air conditioning was installed in 1936.

In 1951, the name of the theatre was changed from the Hudson to the Mount Pleasant. A candy bar was added, but it possessed no popper, meaning that the popcorn was pre-popped and delivered to the theatre in large bags. In 1959, the ticket booth, located in the centre of the lobby area, was relocated to the street line.

Today, the Mount Pleasant Theatre continues to offer two films per show and remains an integral part of the community.

BELSIZE (CREST, REGENT)

The Belsize Theatre at 551 Mount Pleasant Avenue opened in 1927 as an entertainment and movie venue. Its architect was Murray Brown, a Scotsman by birth who opened a practice in Toronto in 1914. He

designed many theatres in the city, such at the Park Theatre (Bedford) on north Yonge Street, but he is not to be confused with Benjamin Brown, the architect of the Art Deco warehouse lofts on Spadina Avenue and the Victory Theatre on the same street. The symmetrical façade of the Regent Theatre contains large windows on the second floor that are topped by Roman arches. The stone trim added to the façade creates a formal but attractive appearance. In the middle of the pediment, below the peaked roof, there is a large stone crest. The roof contains terra-cotta tiles.

The theatre's name, the Belsize, was likely derived from the well-known residential area in London of the same name. The theatre was part of the Famous Players chain. It possessed an impressive lobby and a single screen, set amid an opulent interior that contained arches and fancy plaster trim. The auditorium had a stage area to accommodate live theatre as well as movies. The Belsize had 726 leatherette seats and an additional 205 in the balcony. The theatre opened at a time when the city was expanding northward, and the empty fields and dirt roads of the Mount Pleasant/Eglinton area were rapidly disappearing.

For two decades, the Belsize was a successful neighbourhood theatre. However, in the 1950s, Toronto's theatrical scene was changing. The only theatre of note offering live stage performances was the Royal Alexandra, which featured plays and musicals produced by American touring companies. Many people felt that a theatre that featured Canadian talent was needed. In 1953, the Belsize ceased screening movies. It was renovated and reopened as the Crest, a venue for live theatre.

In 1968, I saw the play *Jack Brel Is Alive and Living in Paris* on the stage at the Crest. In 1980 and 1981, the annual satirical revue, *Spring Thaw*, was staged at the Crest. I remember seeing these shows. It was the first time I saw Barbara Hamilton on stage.

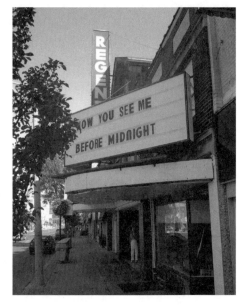

The Regent (Belsize) Theatre in 2013.

In March 1971, the theatre commenced screening films once more. In 1988, it was again extensively renovated and reopened as the Regent. The name Regent had been employed by two of Toronto's earlier theatres. One of them was on the southwest corner of John and Adelaide Streets, but it retained the name between the years 1884 and 1890 only and then became the Majestic. It was demolished in 1930. Another Regent Theatre was located at 225 Queen Street East, west of Sherbourne, but it, too, was demolished.

Thankfully, the old Belsize Theatre of yesteryear lives on as the Regent on Mount Pleasant Avenue.

RUNNYMEDE

When the Runnymede Theatre opened in 1927 at 2225 Bloor Street West, near the southwest corner of Bloor Street West and Runnymede Road, it was an architectural gem in the crown of the Bloor West Village. Years later, when it was threatened with demolition, local residents fought hard to save

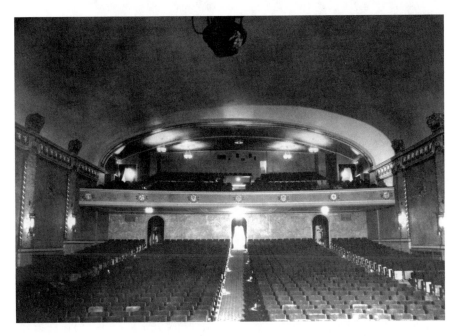

View of the interior of the Runnymede Theatre from the stage. *Ontario Archives, RG 56-11-B116412.*

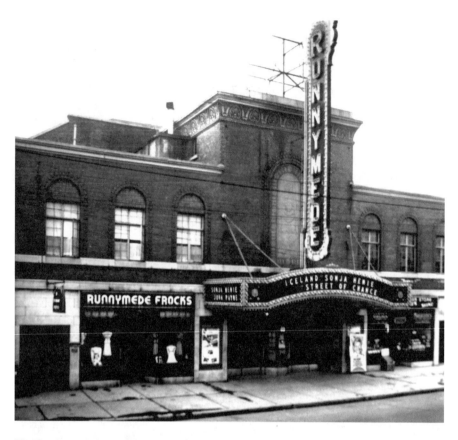

The Runnymede in the mid-1940s. *City of Toronto Archives, Fonds 251, Series 1278, File 147.*

it. Fortunately, the Chapters/Indigo book chain purchased it as a site for a bookstore. It spent $4 million to gut the auditorium and balcony to create a space suited to its requirements. In the process, it restored and maintained the interior walls and stage area.

The Runnymede Theatre was designed by Alfred Chapman, a Toronto architect well known for his work on the Royal Ontario Museum and the Palais Royale at Sunnyside. The theatre's exterior was constructed of red brick and stone. The interior resembled an open-air theatre, with the ceiling painted blue to simulate the sky. Tiny light bulbs in the ceiling resembled stars. Silver and blue images were projected on the ceiling to create a cloudlike effect, as if a person were sitting in a forest under the night sky. The interior walls were in the Spanish style, with ivory stucco and gold leaf, lit by sconces and wall lanterns. Above the exits from the auditorium were plaster

ornamentations. It was the first of twenty-one "atmospheric theatres" built in Canada. The only one that survives today is the Capital in Port Hope, inspired by the Orpheum in New York City.

The Runnymede Theatre commenced life on June 2, 1927, with several vaudeville acts, followed by screening of the film *The Fire Brigade*, the second feature being *Rookies*. The theatre was renovated in the 1930s and its seating capacity increased. During most of the 1970s, it ceased to operate as a theatre and was a bingo hall. It reopened in 1980 as a two-screen venue.

By the time the lease held by Famous Players expired, attendance had declined, and it was no longer profitable to operate the theatre. In 1999, the rent was $35,000 per month. The theatre closed on February 28, 1999. The last film shown at the Runnymede was *You've Got Mail*. The future remains uncertain for the building, as Chapters/Indigo has decided to close the store on the site. However, recent reports suggest that the property will be converted to an outlet for a major drugstore chain.

THEATRES DURING THE 1930s
The Great Depression

W hen the Great Depression of the 1930s descended across the nation, food lines and unemployment became a part of daily life for many residents in Toronto. The difficult economic times were both a blessing and a curse for the movie industry. People could no longer afford to attend theatres as often, but for many, not attending any movies was not an option. As a result, though movie attendance dropped slightly, it remained the most popular entertainment venue as it was relatively inexpensive and was available in almost every neighbourhood.

There was another aspect of the Great Depression that aided the movie industry. It was a decade when people needed to escape the harsh realities of daily life. Movies allowed them to visit imaginary worlds in faraway places, as well as experience drama, comedy, crime, piracy and scorching romance. Because of the popularity of films, the public avidly followed the lives of the movie stars, and any information concerning them was "hot off the press" news. At the same time, the film studios attempted to suppress negative scandals concerning the stars since they might affect attendance at the box office. If stars had extramarital affairs, the studios tried their best to conceal them from the public. Any hint of an actor being gay was considered beyond the pale and never mentioned, even when it was common knowledge within Hollywood. Slush magazines flourished. The entertainment pages in the daily newspapers were eagerly sought and widely read. The glamour of Hollywood was intensely followed, and the movie industry profited from the public's fascination with the world of film.

The 1930s were rather prudish, compared to today. Mae West shocked many with her now famous statement, "When I'm good I'm good, but when I'm bad I'm really good." Another of her notorious quips was, "Come up and see me. I'll have nothing on but the radio."

Hollywood also influenced the lexicon of the times. Everyone knew what was meant by "Betty Grable legs." A standard putdown for an aspiring Romeo was, "Who do you think you are—Clark Gable?" Children echoed the well-known line from the cowboy films, "Let's head them off at the pass." Adults soon adapted the phrase for their own purposes. Film was important to the lives of Canadians, and thus theatres continued to be constructed, despite the economic gloom of the decade.

GRANT

In the 1940s photo of the Grant Theatre, the films on the marquee were both released in 1936. The theatre was located at 522 Oakwood Avenue, where it intersects with Vaughan Road. Of all the theatres in Toronto, the Grant retains the most memories for me, as it was the first movie theatre that I ever attended. I was five years old when my older brother and I departed the family home in 1943 and walked to the theatre, our fifteen cents clutched in our fists. Upon arriving at the theatre, we visited the Oakwood Confectionery Store, next door to the theatre, and spent the grand sum of five cents on penny candy. The gentleman behind the counter was of considerable girth, and my brother informed me that everyone referred to his store as "Fats." We knew nothing in those days about being politically correct.

We purchased our ten-cent tickets at the box office, where a stern-looking lady eyed our coins as if they might be counterfeit. Entering the theatre, we handed our tickets to another woman, who was similar in girth to the man in the confectionery store. However, she had a slight moustache, whereas the man in the candy store was clean-shaven. I later learned that she was not only the ticket-taker but also the theatre's "matron."

In the 1940s, theatres were forced to hire matrons to police the behavior of those who attended their venues. My brother and I thought that the matron at the Grant looked as if she could wrestle "Whipper Billy Watson" in the ring at Maple Leaf Garden. We thought that all matrons looked like she did. As it turned out, this was not true. We later learned that many of the matrons were slender and pretty. However, a menacing appearance was

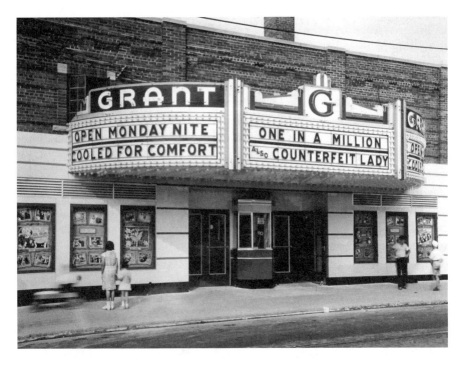

The Grant Theatre, circa 1940. *City of Toronto Archives, Series 1278, File 79.*

an asset for a matron, especially if she encountered a particularly difficult patron. My brother told me that the matron at the Grant wouldn't allow anyone to spit, seat-hop, throw stink bombs or toss popcorn boxes in the air or out into the aisles; above all, she made certain that no one became too frisky with a girl in the back rows of the theatre. I did not entirely understand the latter offence, but it sounded intriguing.

Matrons also patrolled the evening screenings, when mainly adults attended. They ensured that there was no smoking, except in the smoking section, which was in the loges or a few designated rows at the rear of the auditorium. During evening performances, the back rows of the theatres remained under careful scrutiny, should any young couples engage in overly romantic trysts.

I will always remember my first movie experience in 1943. When the curtains opened to commence the first film, the yelling and screaming was sufficient to rock the foundations of the building. The matron, unable to subdue the wild antics of the youthful audience, gracefully slinked back to wherever it was that slinky matrons hid on such occasions.

The first feature of the afternoon was the murder story I described at the beginning of the book. A man wanted to kill his wife, so he tampered with the brakes of her car. Unable to control the automobile, she drove off a steep cliff, and it became a pile of rubble on the rocks below. Each time the murderer drove past the site of the wreck, he gazed down. The film almost scared me to death. The second feature of the afternoon was a skating film, starring Sonja Henie. It bored me to death, and halfway through the film, I departed the theatre. To this day, I have not decided if it is better to be scared to death or bored to death. On second thought, I suppose the answer is neither—it is best to be pampered to death.

The Grant Theatre was a family-owned theatre that opened in 1930. Because it was a neighbourhood theatre, its patrons were mostly from the surrounding residential area, and therefore the theatre was not able to charge downtown ticket prices. As a result, the Grant did not screen recently released films, as they were too expensive to rent. Instead, it showed films that had been released several years earlier and featured two movies per night or matinee. If one of them were classified by the censor board as "adult," then an alternative film was shown at the Saturday afternoon children's matinee. One pair of films was shown Monday, Tuesday and Wednesday, with another two movies on the remaining three days. By law, no movies were allowed on Sundays.

It was at the Grant that I viewed on screen the antics of the "Bowery Boys," a gang of New York teenage ruffians that hung around Louie's Sweet Shop, inventing schemes to make a few dollars. Their leader was Slip Mahoney, played by Leo Gorcey. The funniest character was Horace Debussy Jones, whom the Bowery Boys called "Sach." This character was played by Huntz Hall. The plans of the gang invariably failed, as they were a bunch of clowns at heart. The movies were cheap to produce and generated a vast amount of money for the studios. The Laurel and Hardy and Abbott and Costello movies were similar in this respect. Other popular movies at the Saturday afternoon matinees included those that starred Roy Rogers, Gene Autry or Hopalong Cassidy. Any movie with John Wayne was popular, whether it was a cowboy flick or a war film. We quickly learned that in cowboy movies, the bad guys wore black hats and the good guys wore white. It was a morally simplistic and wonderful world. Perhaps today's politician should adapt the "hat method" of identification so voters will know whether they are bad or good.

The Grant was listed in the newspaper ads in 1952 under "National Theatres," but it was eventually taken over by the Odeon chain. Screenings

commenced at 5:00 p.m. and continued until near midnight. People entered and departed at any hour. When people decided to attend the movies, they simply walked to the theatre, rarely bothering to check when the features started. For this information, it was necessary to phone the theatre, as the newspaper ads did not give the starting times (except for the large downtown theatres). Patrons departed the theatre after viewing the sections that preceded their entry.

The auditorium of the Grant contained 672 seats, and there was no balcony. Blackout curtains were placed across the entries to the aisles to prevent light from the lobby from disturbing the viewing in the auditorium. This was necessary, as patrons were continually arriving and departing. This was not necessary during children's matinees, as they started at 1:30 p.m. and ended when the second feature film was over. The washrooms of the theatre were on the second floor, reached by stairs located on either side of the lobby.

Because theatre attendance was lower on Monday and Tuesday nights, the Grant offered special promotions to attract patrons. Free dinnerware was a favourite, with the women receiving a different piece of dinnerware each time they attended. Sometimes the offer was extended to include weekends as well. While the films were in progress, women sometimes stood up to allow other patrons to enter or depart the aisle where they were seated. Forgetting they had a plate or cup and saucer on their laps, the dinnerware crashed to the floor with a resounding clatter. Each time this occurred, the audience noisily applauded, whistled and cheered. On some nights, the theatre distributed autographed photos of movie stars. As a kid, I always marvelled that Cary Grant, Roy Rogers and John Wayne had the time to sign so many pictures.

My family moved away from the neighbourhood where the Grant was located in 1953, so for several years I was not aware that the Grant Theatre had closed its doors in 1956. Another entertainment venue "bit the dust," as the cowboys of the purple sage would have said.

HOLLYWOOD

The film on the marquee in the 1940s photo is *Ladies of Washington*, starring Trudy Marshall. It was released in 1944. The Hollywood Theatre was at 1519 Yonge Street, on the east side of the street, a short distance north of St. Clair Avenue. Located in Deer Park, it was in an area that developed as a

residential district in the 1890s, after the Yonge Streetcar line was extended beyond Summerhill, northward up over the steep Yonge Street hill north of Davenport Road. Prior to that time, Deer Park had been isolated from the city below. By the time plans for the Hollywood Theatre commenced, Deer Park had developed as a well-established community with expensive real estate prices and excellent shops.

The Hollywood Theatre opened on October 27, 1930, as part of the Allen chain, among its "Premier Group of Theatres." Herbert George Duerr was the architect. Duerr also designed the Major St. Clair and the Village Theatre in Forest Hill Village. The Hollywood was a further advancement in the city's movie theatre scene. Although the "talkies" had first appeared in Toronto in 1928, they were shown in converted silent movie houses. The Hollywood was the first theatre constructed as a "talking picture playhouse," explicitly for sound films. It was equipped with an up-to-date Western Electric Sound System. The first "talkie" at the Hollywood was *Love Among the Millionaires*. This information was derived from an article by Mike

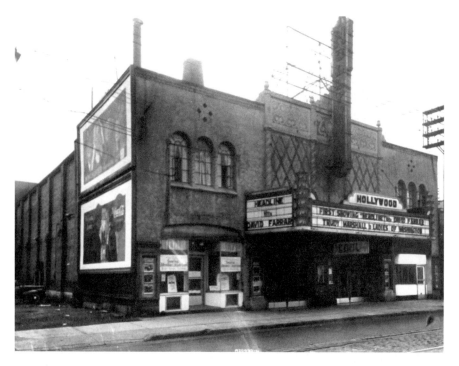

The Hollywood Theatre, circa 1945. *City of Toronto Archives, Fonds 251, Series 1278, File 83.*

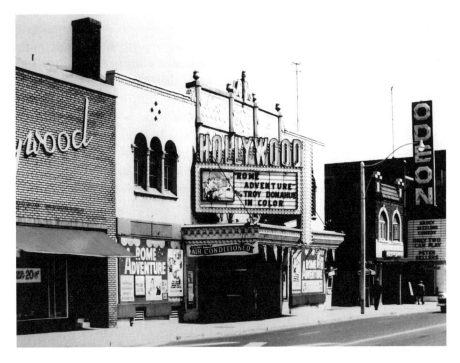

The Hollywood Theatre, circa 1963. The film on the theatre's marquee in the 1960s photo is *Rome Adventure* (1962), starring Troy Donahue. Visible in the photo is the luxurious Odeon Hyland Theatre, a short distance to the south of the Hollywood. The façade of the Hollywood had Moorish-style arches, ornate designs above the marquee and detailed ornamentation in the cornice. I remember this theatre quite well and attended it many times in the 1950s and 1960s. *City of Toronto Archives, Fonds 251, Series 1278, File 83, photo by Ernest.*

Filey that was published in the *Toronto Sun* on March 7, 1999 (found in the files of the City of Toronto Archives).

The Allen chain eventually sold the Hollywood Theatre to Famous Players Corporation. In the 1950s, the theatre was redesigned to create twin auditoriums—a north theatre and a south theatre. The north theatre was built in the space that had previously been the theatre's parking lot. At the same time, the canopy and façade of the structure were also changed. The total cost of renovation was between $55,000 and $60,000.

In the 1950s, as previously mentioned, Ontario laws required that matrons patrolled the aisles of the theatres to ensure that there was no seat-hopping or other improprieties. In 1957, a woman complained in writing to the censor board that she had observed the matron at the Hollywood sitting in the manager's office rather than patrolling the aisles. Later, the woman

saw the same matron reading a newspaper and noticed that her uniform was "messy." The woman decided to explain to the matron how her duties should be performed. Tempers flared, causing the manager to appear. The woman said in her letter to the censor board that the manager's language was "quite abusive."

The censor board investigated the complaint and wrote to the theatre manager. He replied that the woman was crazy if she expected his matron to parade up and down the aisles while the films were being shown. He asserted that he would cooperate with the censor board, but having his matron walking the aisles during films was too visually distracting. However, the manager insisted that the matron was in control of the audiences at all times. I suppose this included the back rows. The matter ended.

In 1960, the censor board received another complaint concerning the Hollywood Theatre. A patron noticed that a child of ten or eleven years of age was seen in the theatre viewing an adult film, *Suddenly Last Summer*. The censors informed the complainant that children were allowed to see adult films on public and school holidays, providing they attended before 6:00 p.m. The person who complained replied that parents should be warned of this rule, as she felt that most parents were not aware of it.

Similar to many of Toronto's great movie houses, the Hollywood became unprofitable when attendance dwindled. It closed in 1999, and the building was demolished.

ORIOLE (CINEMA, INTERNATIONAL CINEMA)

The Oriole Theatre was located at 2061 Yonge Street, on the east side of the street, near Manor Road. The plans for the theatre were submitted to the city by the architect, Kirk Hyslop, and were dated June 1933. The simple, unadorned façade of the theatre reflects the austerity of the Great Depression. It was a modest-sized theatre, with a concrete floor and 576 leatherette seats with plush backs. The balcony was exceptionally small, as the files state that there were only 29 seats. Perhaps it was the loges, reserved for smoking patrons.

The theatre was renovated by Kaplan and Sprachman in December 1941 for Botany Theatres, with the changes completed by May 1942. The Oriole was renamed the Cinema Theatre the same year it was renovated. In about the year 1946, its name was again changed, to the International Cinema. Its

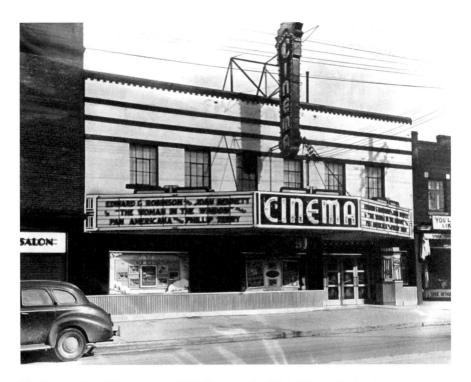

The International Cinema, circa 1945 (formerly the Oriole Theatre), when it was the Cinema. *Ontario Archives, RB 56-11-0-295.*

sister theatre was the Town Cinema at Bloor Street East and Yonge Streets. Both venues specialized in art films and other adult entertainment and did not screen cartoons or other films that appealed to children.

In 1947, the movie version of Shakespeare's *Henry V* played for a record-breaking nineteen weeks at the International Cinema. For the occasion, the theatre was decorated with streamers that were the colours of the French flag. During the 1950s, art exhibitions were displayed in the lobby of the International Cinema. They were curated and arranged by Beatrice Fischer. Air conditioning was added to the theatre in 1954.

EGLINTON

In the mid-1920s, the district of Forest Hill was developing as a prime residential area. However, its main street, Eglinton Avenue, still contained

many open fields, although a few shops had appeared. As the area's population continued to grow, an immigrant from Sicily, Agostino Arrigo Sr., decided to build a theatre in the district. His dream was that it would set the standard for Toronto. Many feel that he succeeded when he struck a deal with Famous Players to construct an eight-hundred-seat theatre at 400 Eglinton West, one block west of Avenue Road. It was designed by the architectural firm of Kaplan and Sprachman, which created the Parkdale, St. Clair and Runnymede Theatres, as well as seventeen other theatres in Toronto. The Eglinton cost $200,000, an astronomical amount of money at the time. To reduce operating costs, the theatre's auditorium was built parallel to the street to allow shops to be constructed to the west of the theatre's entrance.

The Eglinton Theatre opened on April 2, 1936, during the height of the Great Depression. The opening-night film was Jack Oakie's *King of Burlesque*.

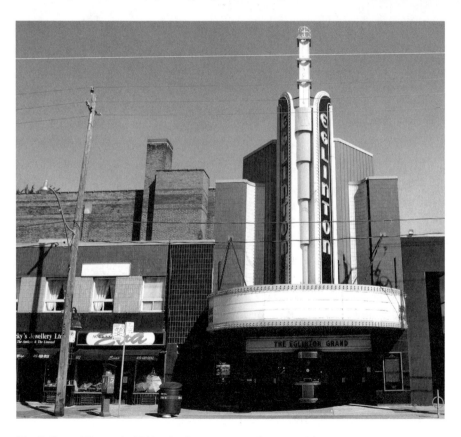

The Eglinton Theatre in 2013, after it was converted to a special events venue.

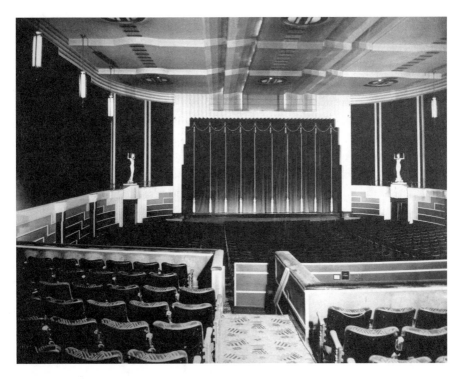

Interior of the Eglinton Theatre in 1947. *City of Toronto Archives, Series 881, File 346.*

The lineups were long, with the patrons paying thirty-five cents for orchestra seats and forty-five cents for the loges and grand circle. These prices were high; the next week the orchestra seats were reduced to twenty-five cents.

The Eglinton was one of the finest Art Deco–style theatres ever built. In 1937, it was awarded the Royal Architecture Institute of Canada Bronze Medal for achievement in advanced Art Deco design. The theatre was inspired by the "Century of Progress Exposition in Chicago" of 1933, which Kaplan attended. The crowning glory of the Eglinton Theatre's marquee was the neon-lit tower that soared above the canopy. At the top of the tower was a pylon, split into three sections, with a flashing ball mounted on top.

The interior of the Eglinton was sleek, modern and attractive. Patrons entered through a well-appointed lobby, descended several steps and entered a foyer with shiny metal trim, coloured neon lights and a fireplace. The auditorium contained subdued neon lights of different colours, etched glass panels, rich fabrics, hand-carved statues and Art Deco chandeliers. The seats were plush and luxurious.

Many great movies were screened at the Eglinton throughout the years. From 1965 until 1967, *The Sound of Music* played for 146 weeks. In 1968, I saw *Finian's Rainbow* at the Eglinton. In 1983, the James Bond film *Octopussy* was shown.

Despite its grandness, the Eglinton closed in April 2002. Interestingly, the reason for its final demise was a dispute over wheelchair access. The owners decided that to provide this feature was too costly, considering the income derived from the theatre.

Many theatre lovers in Toronto retain fond memories of this great theatre. Fortunately, the building was not demolished. It is now a special events venue named the Eglinton Grand, and its spectacular marquee still shines brightly on the avenue in the darkness of the night.

CASINO

In the 1940s photo of the Casino Theatre, the shop containing the Casino Cigar and Coffee Shop was located in the same building, on the right-hand side of the theatre. On the marquee appears Valerie Parks's name. She was a famous burlesque star during this decade.

Throughout the theatre history of Toronto, other than perhaps the Victory Theatre on Spadina, there is no entertainment venue that elicited as much praise, raunchy stories, condemnation and newspaper coverage as the infamous Casino Theatre. Located at 87 Queen Street West, it was on the south side of the street, directly across from today's New City Hall. The antics in the council chamber of the city hall of today pale in comparison to those that occurred inside the Casino during the many decades that it operated in the heart of the city.

My father, my uncles and my grandparents immigrated to Toronto in the early 1920s. My grandmother was a stern woman who held deep religious convictions. She often overheard her young sons talking about a theatre named the Casino and prayed that they would never darken the doors of such a den of iniquity. The theatre was famous for its raunchy comedians and risqué burlesque acts. My grandfather assured her that her worries were unnecessary, as "the boys" had been well taught to avoid such sin traps.

One evening, the boys decided to travel secretly downtown and visit the famous theatre. It was the early days of the Great Depression, and I suppose they thought that the display of a little bare skin might distract their minds

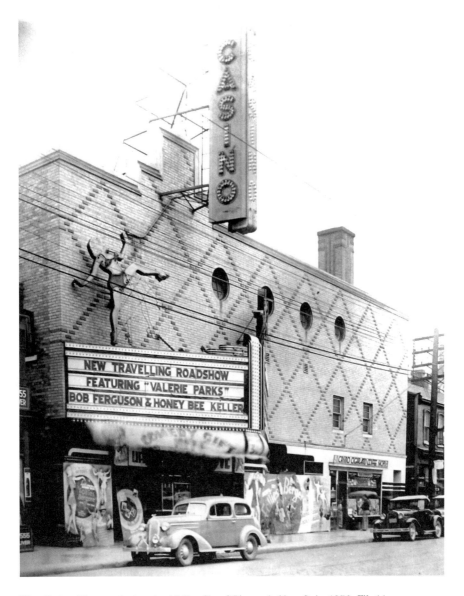

The Casino Theatre during the 1940s. *City of Toronto Archives, Series 1278, File 11.*

from their employment problems. Much to their surprise, when they entered the Casino, they saw their father sitting in the front row. There were many embarrassed faces that evening and creative excuses offered to explain their attendance. However, they all agreed that my grandmother should never learn of their escapades.

When I was a boy in the 1940s, I often heard my father and uncles tell stories of their experiences at the Casino and marvelled that my grandmother never overheard them. To the best of my knowledge, when she passed away in the 1960s, she never knew that her husband and sons had frequented Toronto's most famous burlesque house. I also remember my father saying that during the Depression of the 1930s, if he were unable to secure a job, as a last resort he might seek employment picking the fly buttons off the ceiling of the Casino. These were the days before zippers replaced buttons on the fly in men's trousers. My brother and I felt very mature when we figured out what it was that caused the buttons to pop and thought this was a great joke.

When the Casino was built, it was located in a city block that contained five budget hotels, several pawnbrokers and a few budget clothing stores. There was the Broadway burlesque theatre in the same block, and Shea's Hippodrome Theatre, a vaudeville house, was nearby. All these establishments attracted mainly male clientele. The restaurants in the area were not too classy—the smell of fried onions and grease permeated the air. However, although the Casino was located not too far from Yonge Street, it was discreetly tucked away from the prying eyes of wives and mothers who shopped at the city's main downtown shopping area at Queen and Yonge Streets. It was thus an ideal location for a few "naughty" hours of entertainment.

The theatre was the brainchild of Jules and Jay Allen, two brothers from Brantford, Ontario, who partnered with Murray Little, who owned the Broadway Theatre. The Broadway was just five doors to the east of the Casino site, on the same side of the street. The Casino was to be a burlesque house. They hired the famous architectural firm of Kaplan and Sprachman. The new theatre was to contain an auditorium with a balcony, the combined seating being 1,124 seats. Its façade would possess traces of Art Deco. It would have an orchestra pit in front of the stage and rehearsal space and dressing rooms on the second floor, above the auditorium. Because the Broadway and the Casino Theatres would be close to each other, they felt that it would be possible to attract large numbers of male customers. It was the height of the Great Depression, and prohibition was the law, so there were few places where a man could afford to be entertained. It was also an era when films were heavily censored. All these factors indicated success for a theatre such as the Casino. Additionally, it was a time when men went out to work and women laboured in the home. With so many men unemployed, a burlesque house was ideal to take men's minds off their problems.

The grand opening of the Casino was on April 13, 1936, and it did indeed attract large numbers of men. It was a prudish era, and although the "antics" of the strippers and burlesque shows were tame by today's standards, the stage performances at the Casino outraged many of the decent citizens of "Toronto the Good." They referred to the theatre as a "sin palace." It was also declared that it attracted the criminal elements of the city. Rumours circulated that some of the showgirls were available for private sessions for male customers with the funds. As well, people said that bookies often collected bets and paid the winners within the darkened privacy of the Casino.

The Casino offered three films per day, as well as a comedian, a love band and a girlie show. Toronto's historian, Mike Filey, wrote in an article in the 1993 *Toronto Sun* that the Casino offered "every type of performance allowed by law, and some that weren't." The girls in the chorus who could dance reasonably well were placed in the front row on the stage. The girls behind them simply went through the motions. Chorus girls were paid $27.50 a week, but the striptease girls were paid about $300 per week, for twenty-four shows. This was very tempting money during the 1930s. One attractive young woman, who was hired as an usherette, was persuaded to try her luck on the stage. She was pleased with the raise in pay. It is not known if they placed her in the front line or if she was one of the "rhythm" girls in the back. Many pretty women graced the stage of the Casino. In January 1937, a few minutes after midnight on a Sunday, the "Monte Carlo Girls" were featured. In April 1936, the "Lovely Ladies Ensemble—Paris Nights" was the highlight. The famous Gypsy Rose Lee also performed at the theatre.

On one occasion, the Casino screened the film *The Case of Mr. Conrad*, a short movie depicting a gallbladder operation. During the two times it was screened, fourteen men fainted. In the late 1940s, the Casino was fined $100 for overcrowding. This was considered a steep amount, as the usual fine was $20, even though the maximum by law was $200.

During the 1950s, the Casino attracted rising stars who wanted to hone their skills in front of live audiences. The stars were housed at the Ford Hotel at Bay and Dundas Streets, within walking distance of the theatre. In this decade, the hotel was one of the best in the city. Performers such as Burl Ives and Gordon McRae appeared at the Casino, as did the Jimmy Dorsey Orchestra, Dizzy Gillespie, Jimmy Boyd and Lillian Rush.

During these years, many teenagers skipped school to attend the Casino. To them, the shows were sexy and exotic. The usual ploy was for the boy who was the tallest or the most mature looking to purchase the tickets.

However, sometimes their efforts did not unfold according to plan. On one occasion, the principal of a Toronto high school suspected that his students were going to the Casino. He parked his car on Queen Street and sat in the auto, from which he was able to observe the theatre's entrance. It was not long before he witnessed a group of students from his school trying to purchase tickets at the box office, and he confronted them. The next day, they appeared with their parents in the principal's office. It would be interesting to have been a fly on the wall when this encounter occurred inside the hallowed precincts of academia.

In the City of Toronto Archives (Series 1278, File 37), there is slip of orange paper in the file for the Casino that reveals an amusing story. Apparently, the Casino kept a cat on the premises as a "mouser." The feline sometimes wandered on stage during performances. It did this one evening when a comedian was on stage. He stopped his act, gazed down at the cat and said, "Scram pussy. This is a monologue, not a catalogue."

In September 1957, audiences were delighted by "Claudette the Torrid Temptress and the 7 Lucky Girls." The main film of the day was *Abandon Ship*, starring Tyrone Power. However, by the late 1950s, the number of TV sets in the living rooms across the city had greatly increased. This took its toll on theatre attendance at the Casino. The TV program that had the most effect was *Hockey Night in Canada*. Young men began viewing hockey games instead of watching the girls and adult films at Toronto's famous burlesque house. Then the Horseshoe Tavern at Queen and Spadina mounted a TV screen above the bar and commenced broadcasting hockey games. The marriage of beer and hockey began. Times became increasingly difficult for theatres throughout the city.

In the 1960s, the Casino continued to attract some well-known performers—Tony Bennett, Peggy Lee, Eartha Kitt, Pearl Bailey, Toronto's famous quartet the Four Lads, Johnny Ray, Patti Page, Gene Nelson and Mickey Rooney. These performers stayed at the Royal York rather than at the Ford Hotel.

In 1961, the Casino attempted to clean up its act. It was remodelled and renamed the Festival Theatre. However, all attempts to revive its fortunes failed. When the New City Hall was planned for the land across the street from the theatre, the theatre was sadly out of place. It was time for the grand old burlesque and strip joint to disappear. It was demolished in 1965, and the Sheraton Hotel was constructed on the site.

RADIO CITY

The Radio City Theatre was located at 1454 Bathurst Street, on the west side, a short distance south of St. Clair Avenue West. This theatre holds many memories for me. In 1943, a neighbour took my friends and me to the theatre to see the Walt Disney animated film *Snow White and the Seven Dwarfs* (released in 1937). This was at the height of the Second World War, but I was too young to understand the impact of the dreadful news from Europe. However, I understood the terror that gripped the audience when Snow White bit into the poisoned apple and fell into a deep sleep. Perhaps some adults viewed the prince, who rescued Snow White, as symbolic of the relief that the end of the war would eventually deliver.

I did not attend the Radio City Theatre again until I was a few years older. I was about ten years of age when my parents finally allowed my brother and me to attend theatres that were not within walking distance of our home. Unaccompanied by an adult, we boarded the Vaughan bus at its northern terminal at Vaughan and Oakwood and travelled to the theatre. The fare was three cents. To return home, we boarded the Vaughan bus at

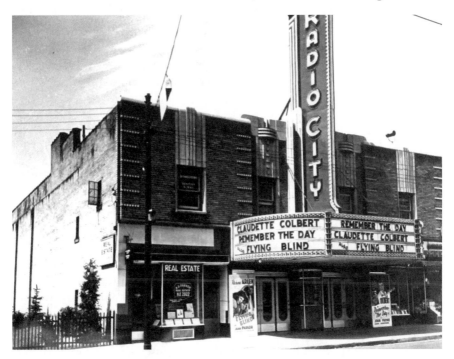

The Radio City Theatre, circa 1942. *Ontario Archives, RG 56-11-0-313.*

93

the loop on the south side of theatre. When my brother and I first attended the Radio City, we felt very grown up. We were convinced that it would not be long before we would need razors.

The Radio City opened in December 1936, named after the more famous venue in New York City. Jay English designed the theatre for R.R. Dennis. It was one of the best of the Depression-era movie houses. Toronto's mini-version of its New York counterpart showed movies and also featured live theatre, as it contained a stage. It possessed 833 plush seats that were "self-raising," meaning that they automatically raised when a person stood to allow someone to enter or depart the row. The theatre contained two aisles but no balcony. Rental shops on either side of the entranceway provided extra income for the owners of the theatre. The theatre was purchased by the B&F chain in 1941 and so eventually became a sister theatre to the nearby Vaughan Theatre (built in 1947).

The satirical musical revue *Spring Thaw* was performed for a few years at the Radio City. In 1958, it opened on Tuesday, April 5, and in 1959, on March 3. The show ceased to be held for several years but was revived in 1980 at the Crest Theatre. The show was also held at various times at the Royal Alexandra Theatre and the Odeon Fairlawn. Devised by Dora Mavor Moore, attending *Spring Thaw* was a popular Toronto tradition for many years.

As theatre attendance dwindled during the 1950s, Radio City became less and less profitable. However, the theatre continued to operate until 1975, when it finally closed and was demolished.

PARAMOUNT

The Paramount Theatre was on the south side of St. Clair Avenue West, between Lauder and Glenholme Avenues. I remember the Paramount Theatre quite clearly, although the 1930s photo does not quite match my memories from the early 1950s, as by then its façade had become decidedly shabby. In the 1930s photo of the Paramount Theatre, the two films listed on the marquee were both released in 1935, so the photo likely dates from 1936, the year the theatre opened. It was named after the famous Paramount Studios in Hollywood, but there was no connection.

The year the Paramount opened, it was licensed to J.B. Goldher and Garson Solway. The auditorium had a concrete floor, and its ticket booth

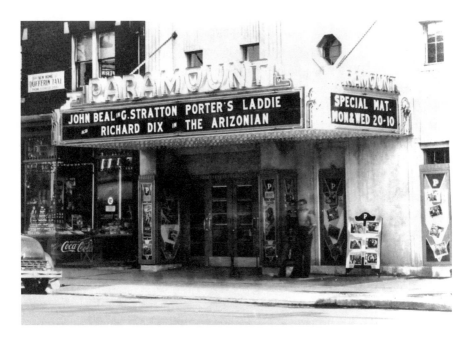

The Paramount Theatre, circa 1936. *City of Toronto Archives, Fonds 1488, Series 1230, Item 1100.*

was in the lobby. It possessed two aisles, with the seating pattern being five seats on the left, an aisle, nine seats in the centre section, another aisle and five more seats on the right-hand side. The air conditioning was water-washed air.

During the 1950s and 1960s, with the advent of television, the Paramount operated on an increasingly tighter budget. It attempted to lure customers by offering three feature films for a single admission price. It mainly screened B-movies and cowboy and crime films, as well as adventure films, cartoons, newsreels and serials. In 1951, the front of the theatre was remodelled by Herbert Duerr. Perhaps this was when the tower was added above the marquee.

When the theatre ceased to operate as a theatre, it became an appliance store. I remember this well, as my friends and I often stopped to watch programs on the television sets in the window. The black-and-white pictures were grainy and of poor quality, but we thought they were marvellous. We dreamed of having such a marvel in our living rooms. When the appliance store was sold, the building was listed by the Toronto Real Estate Board at a price of $100,000. The building that housed the Paramount still exits, but it has been remodelled for other commercial purposes.

SCARBORO

The Scarboro Theatre was located at 960 Kingston Road, on the north side of the street, west of Bingham Avenue. It was in the area of Toronto that I always knew as the Beaches, although it is now officially named the Beach. The theatre's architect was Herbert George Duerr, who also designed the Hollywood Theatre on Yonge Street, as well as the Village Apartments at 404 Spadina Avenue in Forest Hill Village.

When Duerr designed the Scarboro Theatre, he created a building with an unadorned façade of yellow bricks and a plain cornice of stone, in the Art Deco style. The original license for the Scarboro was granted to a Mr. Slate and was held by the B&F chain of theatres. Its auditorium contained almost seven hundred plush seats but no balcony. It possessed water-cooled air conditioning.

The theatre's ownership changed from B&F to 20th Century Theatres in 1948. The same year, in October, a candy bar was installed. In 1949, a fire broke out in the ladies' lounge due to a lit cigarette. The furniture in the room was totally destroyed, and the plaster was severely damaged.

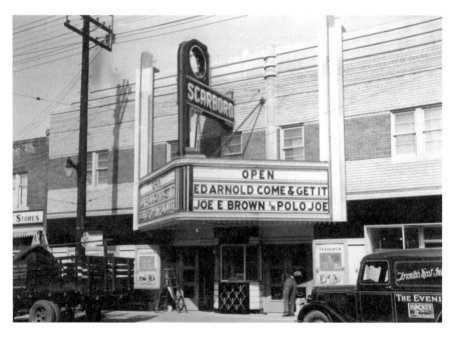

The Scarboro Theatre in 1936, the year it opened. *City of Toronto Archives, Fonds 1488, Series 1230, Item 1128.*

The cost of the repairs was $500, a considerable amount of money at that time. Until smoking was banned in theatres, fires were a constant threat for theatre owners.

In February 1957, a Home and School Association of a school near the theatre refused to place ads for the Scarboro Theatre in its bulletin, as it declared that the theatre screened movies that were "detrimental to our young people, especially teenagers." I would like to know the name of the films that prompted the complaint, as I might wish to view them if they are shown on Turner Classic Movies.

Many theatres in Toronto gave free dinnerware and silverware on weeknights to encourage people to attend. The Scarboro engaged in these promotions as well, but it was one of the very few that also gave away a volume of an encyclopaedia. I remember when the Steinberg Supermarket chain did this, and the brand of encyclopaedia was Funk & Wagnalls. I also can recall when Silverwood Dairy gave free silver-plate serving spoons to its customers. The spoons curled around the neck of the bottles.

I was unable to discover when the Scarboro Theatre closed.

PARADISE (EVE'S PARADISE)

The film on the marquee featuring the ice-skating star Sonja Henie was released in 1936. Fortunately, the building that contained the Paradise Theatre still exists today. It is located at 1008 Bloor Street West, on the northwest corner of Bloor and Westmoreland. Its architect was Benjamin Brown, who also designed the Victory Theatre at Dundas and Spadina. Brown was one of the city's finest twentieth-century architects, having designed several Art Deco buildings on Spadina that remain in existence today—the Tower, Balfour and Reading buildings. Born in Lithuania in 1890, he immigrated to Canada as a child with his family and received his education in Toronto. Most of his buildings reflect the Art Deco style, and the Paradise was no exception.

In 1909, a theatre named the Kitchener had been built on the site where the Paradise was to be located. When the Paradise opened in 1937, it was the height of the Great Depression. Although money was scarce, the theatre's opening was well attended. It contained 643 seats, with 466 in the auditorium and an additional 177 in the balcony, all of which had plush backs and leather seats. It possessed two 35mm projectors, broadloom-covered floors

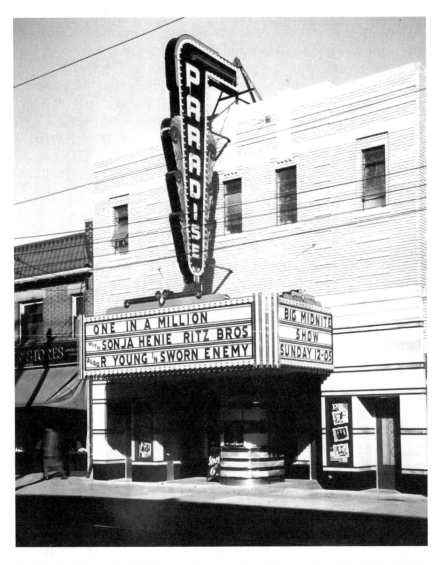

The Paradise Theatre in 1937, the year it opened. *City of Toronto Archives, Series 1278, File 127.*

and air conditioning. The original cost of the theatre was $110,000, not including the equipment. It also possessed a stage to accommodate live theatre or musical acts, as well as two dressing rooms for the actors—one to the left of the stage and the other to the right.

For a brief period in the 1980s, the theatre changed its name to Eve's Paradise and screened movies that today would be referred to as soft-core

porn. The theatre closed in 2006, and although it still exists, it remains vacant. I have been fearful that it might be demolished, even though it is officially listed as a Heritage Building. The laws protecting architectural gems such as the Paradise are too weak to prevent it from a fateful meeting with the wrecker's ball eventually.

However, I have recently learned that it is to be restored. I truly hope that the plans for this fine theatre succeed.

STATE (BLOORDALE)

The Bloordale Theatre was designed by the architects Kaplan and Sprachman, Toronto's prolific theatre designers. From the 1920s until the late 1960s, they designed more than three hundred theatres across Canada. For the Bloordale Theatre, Kaplan and Sprachman chose the Art Deco style, with strong vertical lines and an unornamented stone cornice. It was located at 1606 Bloor Street West, on the north side of the street, between Dorval Road and Indian Grove. The theatre opened as a venue for moving pictures and vaudeville, although the stage did not have the facilities for moveable scenery. It possessed almost seven hundred seats, with two aisles and no balcony. However, the theatre received permission to allow standing room for forty patrons behind the back row.

In 1938, the theatre featured Sunday afternoon amateur competitions, broadcast at 2:00 p.m. over CKCL. The program was entitled *Do You Want to Be an Actor?* Admission was free, which circumvented

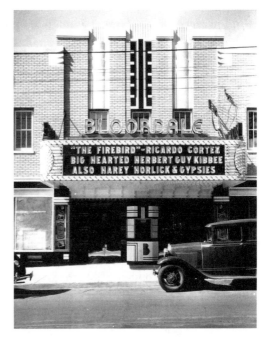

The Bloordale Theatre. This photo was likely taken in 1937, the year it opened. *City of Toronto Archives, Fonds 1488, Series 1230, Item 1103.*

the Sunday closing laws. The shows were sponsored by the Hudson Coal Company. The name of the Bloordale was eventually changed to the State.

As a teenager, during the summer months, I worked at the Dominion Bank at Bloor Street and Dovercourt Road. I travelled on the Bloor streetcar to work and passed the theatre every weekday. Like any teenager, I always glanced out the streetcar window to view the films advertised on the Bloordale's marquee. However, I was never inside it. The theatre closed in 1968, but the structure survives today, although the building is employed for other commercial purposes.

COLONY

The Colony Theatre was at 1801 Eglinton Avenue West, a short distance east of Vaughan Road. The sign on the building in the background of the 1948 photo advertises "Orange Crush." The name of that beverage may create a few fond memories for those who remember the crinkly amber bottles with the soda pop that contained real pulp, as the radio commercials declared. I remember collecting Orange Crush bottles when I was a boy. I returned them to a drugstore to retrieve the two-cent deposit that had been paid by the person who originally purchased the drink.

When I was a young boy, the Colony Theatre was the second movie house that I ever attended. Our local theatre was the Grant, at Oakwood and Vaughan, and since the Colony was farther away, my parents were reluctant to allow me to travel the extra distance, even though I walked. My friends and I considered the Colony to be a "step up," as it was classier than our usual haunt. I attended many afternoon matinees at this theatre, munching on popcorn and being thrilled by the heroes of the silver screen. One of the most thrilling movies I ever watched at the Colony was the 1940s film *Zorro*, starring Tyrone Power. I also attended many sessions of the Saturday Morning Movie Club at this theatre.

The theatre was built in 1939, the year the Second World War commenced. Its architects, Kaplan and Sprachman, designed a yellow-brick building with a plain façade. In 1952, the theatre was purchased by the Odeon chain and extensively renovated. The Colony closed in 1958. The building was gutted, although some sections of the walls were retained. Today, it is the site of an office building.

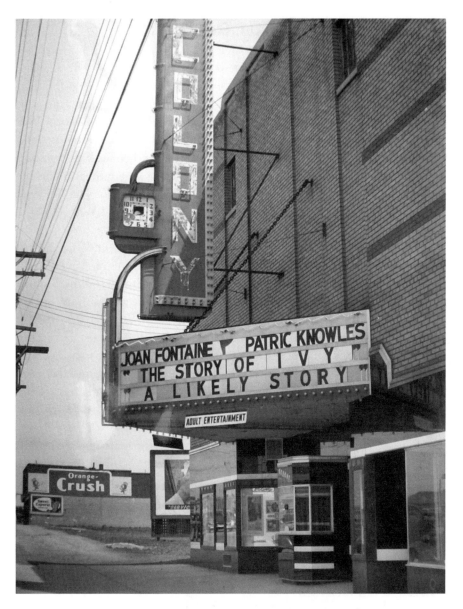

The Colony Theatre in 1948, when the lot to the west of the theatre remained empty. *City of Toronto Archives, 125064.*

BELLEVUE (LUX, ELEKTRA, LIDO)

In 1939, the Bellevue Theatre opened its box office at 360–62 College Street. The theatre was on the north side of College Street, one building to the west of Brunswick Avenue, which extends south into the heart of the Kensington Market. The year the theatre opened, the Second World War commenced, and many of the troops who were training in Toronto attended the theatre until they were shipped overseas. At the end of the war, the shop to the east of the theatre was Smith's Sandwich Bar, where theatre patrons were able to purchase a snack either before or after a movie. The Bellevue continued screening films until 1958, and customers phoned WA 1-1633 if they wanted to know the starting times of the movies.

In 1959, the name Bellevue was changed to the Lux, and the theatre became a burlesque house. Within a short time, it was infamous. The Lux was in direct competition with the Casino on Queen Street and the Victory on Spadina for connoisseurs of the subtle art of the partial removal of clothing to the accompaniment of thumping music.

For the opening of the Lux in 1959, the owner of the theatre flew in the famous stripper "Cup Cakes Cassidy" for a one-night performance. I vividly remember her visit to the city. I was a young man at the time, and the news that this famous entertainer was removing "almost" all her clothes on the stage of the Lux caught my attention. However, the strip shows at the Lux

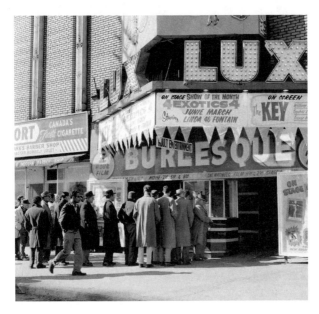

The Lux Burlesque Theatre. *City of Toronto Archives, Fonds 1257, Series 1057, Item 473.*

and other such venues were never as daring as they were advertised to be. I don't recall how I discovered this.

Hard times eventually fell on the Lux. During a labour dispute, picket lines prevented customers from attending, and with the decline in popularity of burlesque, the Lux Theatre closed in December 1962.

In 1968, the Lux changed names, becoming the Elektra Theatre, and showed Greek movies. This ended in 1970, but in 1976, it again reopened as the Lido Theatre and screened Asian films. The theatre was eventually closed permanently, and the building was demolished in 1986.

KINGSWAY

The Kingsway Theatre, at 3030 Bloor Street West, is located in the attractive Kingsway Village, a short distance west of Royal York Road and the Royal York subway station. It is an ideal location, as the street in front of the theatre has much vehicle and pedestrian traffic. The community is fortunate that this historic theatre has survived for more than seventy years. However, its survival has not occurred without considerable effort on the part of its present-day owner, Rui Pereira. And best of all, the theatre features first-run films, as opposed to screening movies that are readily available on DVDs or other electronic formats.

The seven-hundred-seat Kingsway Theatre opened its doors in 1939, the year the Second World War commenced. Its façade contains elements of Art Deco, particularly evident in the parapet that rises above the centre of the plain cornice, at the top of the building. Near the midway point of the façade, there is a horizontal row of cut stone (it's possible it is concrete) that has been inserted into an otherwise relatively unadorned, yellow-brick façade. The pilasters (fake columns) constructed from bricks ascend from above the marquee to the roofline and are capped in the same material as the parapet. The impressive marquee is positioned flat against the façade. The theatre originally had an enormous marquee, triangular in shape, that obscured most of the front of the building. I have been unable to discover when the present-day sign was added or when the marquee was changed to one that possesses curved lines.

In 1954, the Kingsway's theatre license was transferred to Twinex Century Theatre Company. That year, the staff consisted of a manager, two ushers, a doorman, a matron and three candy girls. The theatre was taken over by

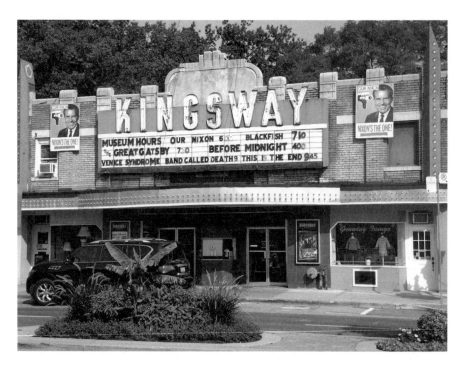

The Kingsway Theatre in July 2013.

the Festival chain of theatres, which also owned the Fox, Revue and the Royal. This company folded in 2006, and the Kingsway remained vacant for two and a half years. It was eventually purchased by Rui Periera, who renovated the old theatre. Carpets were replaced, the seats reupholstered and the washrooms refurbished. The front doors were replaced and a new candy bar installed. Several letters in the large neon sign on the theatre's façade were repaired. The theatre reopened on January 2, 2009.

To attend the Kingsway Theatre today is to experience a piece of living history, harkening back to the days when local theatres were the centre of entertainment in communities throughout Toronto. The city is fortunate that this fine theatre has been preserved.

ROYAL (PYLON, GOLDEN PRINCESS)

The Royal Theatre at 608–10 College Street, near Clinton Avenue, is today in the heart of a district that is referred to as Little Italy, although it

has a substantial Portuguese community as well. When the Royal opened at the end of October 1939, it was named the Pylon and was located in a predominately British community. The choice of the name Pylon is unknown, but in ancient Egypt, it was the name given to the entrance to a grand temple. Perhaps the owner of the Pylon Theatre wished to portray that to attend the theatre was to enter a place of great significance.

The theatre's original owner was a woman named Ray Lewis, who was born Rae Levinsky in Toronto in 1883. She was determined to create a truly special entertainment venue, as she included a roller-skating rink at the rear of the theatre and a dance hall on the second floor. Ray Lewis was the editor-in-chief of the *Canadian Moving Picture Digest* and eventually became its owner. She was influential in the Toronto theatre scene at a time when it was not common for women to engage directly in owning and managing companies.

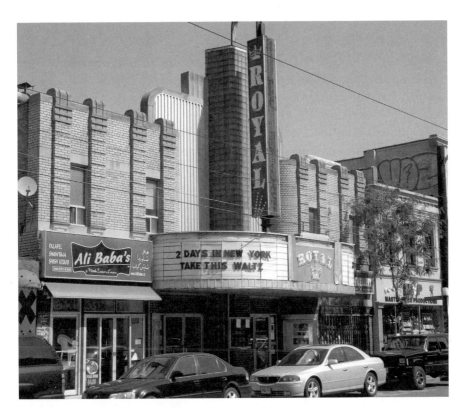

The Royal Theatre on College Street in 2013.

The architect of the 749-seat theatre was Benjamin Swartz, who designed the old Mount Sinai Hospital on Yorkville Avenue, as well as many homes, factories and apartment buildings throughout the city. The Pylon was built in the Art Deco style, with a yellow-brick façade possessing raised columns (pilasters) of brick that rose from above the ground-floor level to the cornice at the top of the building. The pilasters were crowned with caps of stone. The rows of bricks created strong vertical lines that dominated the façade. Today, the theatre retains its original marquee, although the sign above it is different and now reads the Royal instead of the Pylon.

During the 1940s, the theatre held matinees for children, pioneering the idea of encouraging adults to attend, although they were seated in a separate section of the auditorium. I find it difficult to believe, but the theatre claimed that it worked well. In this decade, the theatre also was a venue for children's parties for Jewish and Roman Catholic organizations. In the evenings, amateur talent nights were offered, as well as short-subject films. The name of the theatre was changed from the Pylon to the Royal when the old Royal Theatre at Dundas and Dufferin closed.

In the late 1950s and 1960s, because the demographics of the neighbourhood had changed, the theatre screened Italian films. Rocco Mastrangelo, the owner of the Bar Café Diplomatico on College Street, purchased the theatre. He also bought the St. Clair Theatre and showed Italian films at both venues. Interestingly, the Bar Café Diplimatico survives to this day. In the 1990s, the theatre was renamed the Golden Princess and screened Asian films.

The theatre eventually became part of the Festival chain of theatres and reverted to its original name, the Royal. In 2006, the chain folded, and the theatre became independently owned. Today, it is an integral part of the scene on College Street in Little Italy. It screens recently released and second-run movies, as well as independently produced art films. During the day, it is rented for studio and rehearsal space.

METRO

The Metro Theatre, at 679 Bloor Street West, is located in an area that today is referred to as Korea Town, due to the number of Korean restaurants and shops located there. The theatre is on the south side of Bloor, a short distance from Manning Avenue. The Metro commenced operation in 1939,

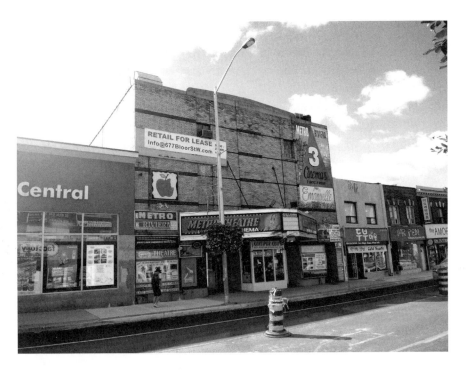

The Metro Theatre during the summer of 2013.

one of the last theatres to open before the outbreak of the Second World War. It was a welcomed addition to the four other neighbourhood theatres along that section of Bloor Street. On opening night, a fire broke out in the Metro. There was not much damage, but the fire created much free publicity as the event was reported in all the newspapers.

The theatre was intimate in size, containing only about three hundred seats. The box office was originally in the centre of the entranceway. Its architects were Kaplan and Sprachman, and it was one of the last theatres they designed with touches of Art Deco. The yellow-brick façade was quite plain, with rows of raised bricks forming vertical columns that extended upward to the plain cornice. Atop the building was a stone parapet with rounded edges, clearly influenced by Art Deco. When it opened, its marquee was at a right angle to the façade, but in future years, it was flattened against the wall; eventually, the marquee was entirely removed, with only the canopy remaining.

The Metro never featured first-run films, instead choosing to show grade-B films. In 1978, the theatre began showing porno movies and offering

burlesque. However, VCRs in homes soon diminished the popularity of porno films, though the Metro continued showing them and became known as "Toronto's last porno house." The theatre eventually deteriorated and became rather seedy.

The Metro was renovated in 2012 and brought back to life. It specializes in adult movies and art films. It is also rented out for special events.

THEATRES IN THE 1940s

The Second World War and the Postwar Years

B etween the years 1940 and 1945, theatre construction came to a near
standstill, as the resources and workforce of the nation were geared
to winning the war. However, theatres continued to be well attended and
played a major role. Other than photographs in newspapers, newsreels in
theatres were the only visual images of the war. They aided the Allied cause
by showing scenes of victories on the battlefield, and if there were a disaster,
the true number of casualties was not mentioned or was underestimated.
They also captured inspiring episodes such as those that showed King
George VI and Queen Elizabeth amid the bombed ruins of Buckingham
Palace. Scenes of the royal family touring the bombed sites in London
inspired Allied nations across the globe. War heroes were also featured.

Hollywood and British war films were created to be inspirational. Today,
watching these films, they may appear overly simplistic. The enemy was
portrayed as vile and cowardly and the Allied forces as always brave and
virtuous. These movies became an important tool of war, as they asserted the
justice of the Allied cause and reassured people that victory over the enemy
was a certainty. The 1944 movie *The White Cliffs of Dover* is an excellent
example. The speech narrated by Irene Dunne at the end of the film is
inspirational, and even now, listening to it is an emotional experience.

Movies aided the war effort in other ways as well. They attempted to
provide escapism for a public that was weary from casualty reports and
battle news. For example, the extravagant MGM musicals helped soothe
the wounds of war, and for a few hours people could forget the reality that

bombarded them daily. I remember viewing films such as *For Me and My Girl* (1943) with Gene Kelly, *Girl Crazy* (1943) with Mickey Rooney and Judy Garland, *Meet Me in St. Louis* (1944) with Garland and *Anchors Away* (1945) with Frank Sinatra and Kathryn Grayson. I was too young to realize the effects of these films on the general public, but I was aware of the enjoyment they created for me. Interestingly, Mickey Rooney was one of the longest-surviving stars of this era. He died in April 2014.

Movies were an important part of my boyhood in the 1940s. In those years, I recognized very few faces of the players on Toronto's hockey and baseball teams, as other than the occasional picture in the newspapers, I never saw them. However, I was familiar with the faces of many movie stars, as I saw them every week at the local theatre. Bubble gum companies cashed in on this by adding "movie star cards" in their packages of gum. For the price of two cents, I received the gum and a card with a photo-portrait of a movie star. I traded duplicate cards with friends in the schoolyard. Many a morning, I departed for school with a thick wad of cards in either my pocket or my hand. Trading cards was an enterprising pastime. I do not recall seeing hockey and baseball cards until after I became familiar with sports heroes via television.

After the war ended, for the next few years, films about the conflict continued to dominate the theatres of the city. Although the war years had eliminated some of the inhibitions and prudishness of earlier decades, the Ontario Censor Board maintained tight control over what was acceptable to be seen in films. In August 1944, it became mandatory that all photos that advertised movies, both the interior and exterior displays, be submitted to the Ontario Censor Board for approval. Some jokingly referred to it as the Ontario Senseless Board.

When the men returned from overseas, they discovered that life in Canada had changed. The women who had replaced men in the factories manufacturing munitions and war supplies continued to play a major role in the workplace, and as Canada converted its industries from the war effort to peacetime production, the economy boomed. People had money in their pockets and wished to purchase homes located in the suburbs. Automobile sales soared, creating neighbourhoods surrounding Toronto that were geared to families with cars. Theatre owners responded to these changes and provided large parking lots near their theatres. Downtown movie houses also continued to thrive, but their architecture now was more likely to possess smooth façades of concrete or stone, as well as large windows that allowed those who passed on the street to view their

modern interiors. These modernistic theatres appeared in both the inner city and in the suburbs.

As the 1940s drew to a close, the difficult days of the war years slowly receded from the minds of Canadians. Casualty reports and food rationing no longer dominated life. Theatre attendance boomed.

UNIVERSITY

Perhaps one of the most impressive theatres constructed in the postwar period was the University at 100 Bloor Street West, between Bay Street and Avenue Road. A project of by Famous Players Corporation, the excavation and the pouring of the cement foundations were completed on April 17, 1947. On March 25, 1949, the University Theatre thrust wide its doors to an eager public. The architect was A.G. Facey, who also designed the Nortown. The University Theatre's smooth granite façade was sleek and modern, with gentle curves. Its lobby was two storeys in height, and its Art Moderne marquee towered skyward. Its auditorium contained about 1,350 seats, installed by the Canadian Theatre Chair Company. It possessed Dolby sound and an enormously wide screen, ideal for epic films. However, despite the theatre's size, the critics said it was too intimate to be referred to as a "movie palace." In a way, this was a backhanded tribute to the atmosphere created by the designer of the theatre's interior, Eric W. Hounson.

The film on opening day was *Joan of Arc*, starring Ingrid Bergman. The matinee tickets were $0.75, but it was $1.20 to attend an evening performance. A reporter wrote, "The film spread itself like a colourful mediaeval tapestry over the screen…a pageant, rather than a re-creation of history…a spectacle rather than a drama." Some felt that Bergman was too old to play the teenager heroine Joan of Arc. Others said that perhaps the theatre was the real attraction, not the opening film.

My grandfather thought that the theatre and the film were magnificent. He had been the night watchman during the theatre's construction and appreciated the complimentary pass he received to view the opening film. However, the completion of the theatre meant that he lost his job. My grandmother was relieved, as she thought him too old to be travelling downtown at night to the construction site.

As a teenager and as a young man, I enjoyed many excellent movies in the University Theatre. In 1956, I purchased an advanced-seating ticket to view

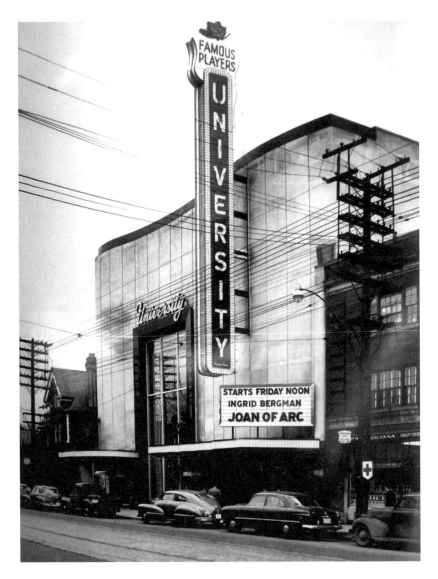

The University when it opened in March 1949. *Ontario Archives, RG 56-11-0-323.*

The Ten Commandments. In 1958, the theatre introduced Cinerama to the city. In 1962, the film *Ben-Hur* played at the University. Because of the movies I saw in the theatre, in my mind, Charlton Heston was forever a towering hero—Moses or Judah Ben-Hur. In 1962, I also saw *Lawrence of Arabia*, a lengthy film that almost gave me camel sores. Fortunately, the plush maroon-

coloured theatre seats compensated, as they were soft and comfortable. However, the desert scenes dehydrated me, and at intermission, I gulped two containers of Vernor's Ginger Ale.

I saw *Cleopatra* at the theatre in 1963, starring Elizabeth Taylor and Richard Burton. Watching passion amid the pyramids was a great thrill. In the 1965 movie *Doctor Zhivago*, directed by David Lean, the winter scenes, filmed in Canada, were gorgeous. However, my rear end almost froze. Lara's theme did not compensate, although Julie Christie was "hot."

In 1965, Charlton Heston played the role of Michelangelo in the film *The Agony and the Ecstasy*, based on the novel by Irving Stone. Why he became head of the National Rifle Association was always a mystery to me. In the movies, he was a hero who represented valour and justice, but I was never able to find any justice in promoting unrestricted gun sales. Today, I wonder if conservative-minded Charlton Heston was ever bothered by performing the role of Michelangelo, since he was portraying a gay man. Despite my perceived sufferings at the University, I consider myself fortunate to have attended this magnificent theatre.

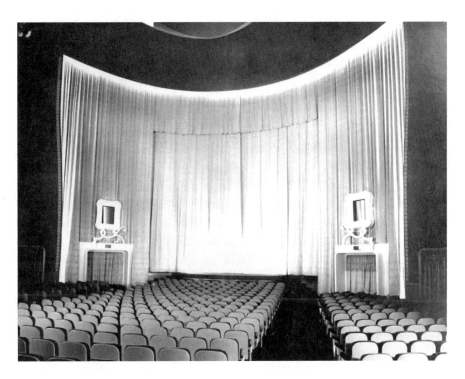

Auditorium of the University Theatre. *City of Toronto Archives, Series 881, File 336-17A.*

However, during the years that I attended the University, the economics of operating theatres slowly changed. In the 1980s, the manager of the theatre stated that even if another film came along such as *Apocalypse Now*, which had played for fifty-two weeks at the theatre, it was not possible to keep the University open. Eventually, it was offered for sale. The Toronto Historical Board attempted to have it designated a Heritage Building, but the request was denied.

When they locked its doors in 1986, a truly great movie auditorium was lost. Today, the theatre's façade is part of a condominium. This is all that remains to remind Torontonians of its existence. Great theatres such as the University can never be replaced. Our Heritage Buildings disappear, and it seems that very few lament their passing. Years later, when they demolished Loew's Uptown, my sentiments were similar.

ODEON FAIRLAWN

Another of Toronto's great postwar theatres was the Odeon Fairlawn. The plans for the theatre were submitted to the City of Toronto by the architect Jay English in December 1945. The sleek, ultramodern theatre opened two years later, on August 14, 1947, at 3320 Yonge Street, a short distance north of Fairlawn Avenue, in North Toronto. The theatre contained 1,165 seats, plus another 754 in the balcony. It was owned by Snowden Investors Ltd. but leased to the British Odeon chain. Its first manager was Howard F. Elliott. The Fairlawn was the Odeon chain's first entry into the Toronto theatre scene, in direct competition with the American companies that dominated Toronto during the 1940s. The year after the Fairlawn opened, its architect, Jay English, was hired to design the flagship theatre for the company—the Odeon Carlton. He also redesigned the lobby of the Fox Theatre on Queen Street East. This theatre survives to this day.

In 1948, the Fairlawn held a "Casanova Contest," selecting four young women to be judges. They chose a twenty-year-old man, Edward King, as the winner. It was at the Fairlawn that the chain introduced Saturday morning matinees to Toronto, naming them the "Saturday Morning Movie Club." The idea was a success, and the company started similar clubs at its other theatres. As previously mentioned, I remember attending them when they were offered at the Colony Theatre, on Eglinton West near Vaughan Road. Unlike other matinees, they had an emcee who

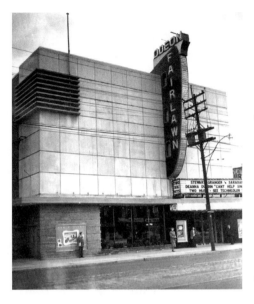

The Odeon Fairlawn. *City of Toronto Archives, Globe and Mail Collection, Fonds 1266, Item 135157.*

introduced the films, and there were also lucky draws and contests. I believe that they also distributed small badges, which we pinned to our shirts or jackets. It may all sound pretty hokey to children today, but in the 1940s, we were proud to wear them.

During the 1950s and 1960s, the Fairlawn had many successful long-term showings of popular films. These included such classics as *Lord Jim*, *Funny Girl* and *Lawrence of Arabia*. These movies often had their debuts at other theatres but settled in at the Fairlawn for the long haul, often for many months and sometimes a year. I remember seeing *Cabaret*, starring Liza Minnelli and Michael York, at the Fairlawn and can recall the long lines outside to purchase tickets.

In 1976, the theatre was redesigned, creating a separate auditorium in the space that had formerly been the balcony. This necessitated building another projection booth to accommodate the new auditorium. The marquee was also altered.

The theatre remained popular throughout the early 1980s but abruptly closed on December 31, 1985. It was demolished, and a retail/residential complex was erected on the site. The city lost a grand movie house, the loss being particularly felt by the residents of North Toronto.

VAUGHAN

The Vaughan Theatre disappeared from the Toronto scene many decades ago, but it remains vivid in my memory. I especially recall that when I was a boy, on hot summer days, when the streets of Toronto sizzled with heat, the air-conditioning system at the theatre was "goose bump" cold. I saw the

film *Francis the Talking Mule* at the Vaughan. As I was a preteen at that time, I thought it immensely funny. In the film, I still remember the corny line when Francis told Donald O'Connor, "I received my information from the FBI—Feed Bag Information."

The ultramodern doors of the Vaughan Theatre, facing St. Clair Avenue, were large sheets of glass, with no metal frames around them. In the lobby area, there was a sleek candy bar, and on either side of it were sloped ramps that led up to the auditorium. The seats were extra plush and the royal-red stage curtains rich and velvety. When they majestically parted to indicate that a feature film was to begin, it was as if a window on the world had opened. At the Vaughan in 1952, I remember viewing the film *Son of Ali Baba*, starring a very young Tony Cutis and the beautiful Piper Laurie. In the movie, when the magic carpet flew over Bagdad, I felt as if I were floating away to realms beyond my wildest dreams.

The Vaughan opened in 1947, operated by B&F Theatres. It seated one thousand moviegoers, more than the companies' other two large theatres—the Donlands in East York and the Century on the Danforth. The Vaughan was designed by Kaplan and Sprachman, the architectural firm that created the designs for many of the city's finest theatres—the Casino, Eglinton, Downtown, Bellevue, Colony and the Town Cinema.

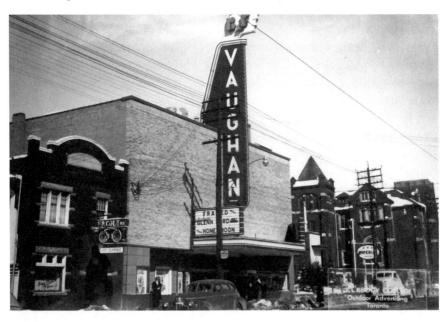

The Vaughan Theatre, circa 1948. *City of Toronto Archives, Fonds 251, Series 881, File 350.*

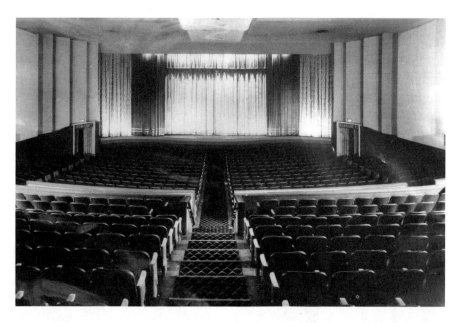

Interior of the Vaughan. *Ontario Archives, RG 56-11-0-324.*

The Earlscourt History Club, in a post published in November 2009 on its blog, stated that there is a story about a man who hanged himself in the Vaughan Theatre on its opening night. Lore has it that the building became haunted. As a preteen, I never heard this rumour, but if I had, it would have added to the appeal of this grand theatre. Unfortunately, the only goose bumps I experienced in the theatre were from the air conditioning rather than from a ghost.

The Vaughan Theatre was demolished in the 1980s, and several commercial buildings now occupy the site.

ODEON DANFORTH

Similar to the other theatres in the Odeon chain—the Carlton, Humber, Fairlawn and Hyland—the Odeon Danforth originally featured mainly British films. The theatre was located at 635 Danforth Avenue, on the south side of the street, a short distance west of Pape Avenue. Two other theatres had existed on the site of the Odeon Danforth prior to the Odeon chain purchasing the property—the Rex and the Athena Palace Theatres. They

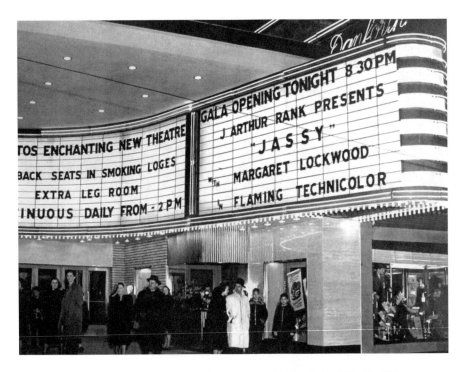

The Odeon Danforth Theatre in 1947. *City of Toronto Archives, Series 1278, File 119.*

were demolished. The Odeon Theatre opened in 1947 and was designed by Jay English. It contained 852 seats in its auditorium and another 476 in the balcony. Because I lived in the west end of Toronto, I was never inside the Odeon Danforth.

In 1964, faulty wiring at the Odeon Danforth caused the popcorn machine at the concession stand to catch fire. Patrons were immediately evacuated. The theatre passed out 587 free tickets for a return visit, although thirteen people requested refunds. The damage was minimal, mostly caused by the thick smoke, but the repair bill was $50,000. In March 1965, another fire occurred in the balcony, caused by a cigarette butt smouldering in a seat. The seat was removed, cut open and thrown into a snowbank outside the theatre. The disturbance was minimal.

The Odeon Danforth closed in the late 1960s or early 1970s. Today, there is a commercial building on the site.

GLENDALE

The Glendale Theatre was opened in late December 1947 by United Century Ltd. and leased to Twinex Century Corp. It was located at 1661 Avenue Road, on the east side near Brookdale Avenue. The first manager was Grant Garrett. When it opened, it was located in a suburb of the city. The Glendale possessed a large parking lot, a feature not common in that decade, although cars were being purchased in increasing numbers. The Glendale contained a luxurious lobby and seating for almost one thousand patrons in its auditorium and balcony.

A confection booth was incorporated into the lobby for the opening, but no popcorn was allowed. At first, I wondered if the reason for the popcorn ban was because it was so good that it was considered a sin. I eventually discovered that the theatre owners disliked popcorn because patrons tended to drop it on the floor, creating a mess. Also, at children's matinees, the popcorn boxes were often thrown as missiles and were dangerous if they hit a child in the eye. However, when popcorn vendors set up their stands

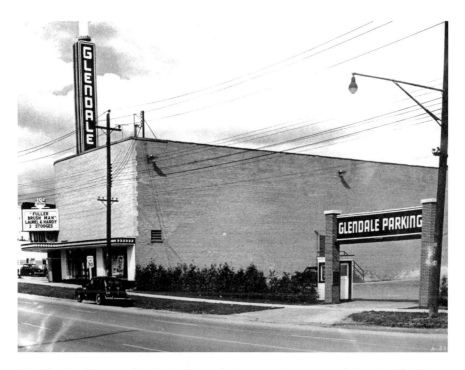

The Glendale Theatre, circa 1949. The main feature on the marquee is the film *The Fuller Brush Man*, starring Red Skelton. *Ontario Archives, RG 56-11-0-293.*

outside the theatres, the theatre owner relented, as they suffered the mess anyway and lost the profits to be had from selling the fluffy treat.

In February 1952, three teenagers were forced to leave the theatre after it was discovered that only one of them was of age to view an adult film. An older boy had purchased the tickets for his two companions, and the doorman had allowed them to enter. He was warned to be more vigilant in enforcing "Section 9."

In 1962, the theatre was warned about advertising posters, located in the lobby, that were not "sniped." The inspector who filed the report stated that the theatre should employ snipes more freely. When the report arrived at the censor board offices, an official exclaimed, "What the hell are snipes?" It is to be assumed that "snipes" was the inspector's word for strips of paper that covered the objectionable parts of posters.

The film *2001: A Space Odyssey* played at the Glendale for two years. I can recall viewing the film there. I saw it again on the big screen at TIFF's Bell Lightbox in 2012. I marvelled at the quality of the photography and enjoyed the glorious soundtrack. Cinerama commenced in Toronto at the University Theatre in 1958 but was last seen in Toronto at the Glendale.

As theatre attendance declined and the property values on Avenue Road skyrocketed, the theatre was sold to developers. The last film to be screened was in 1974—*The Godfather Part II*. Today, there is a Nissan dealership on the site.

ODEON HYLAND

The film featured on marquee in the 1940s photo is *October Man*, a mystery film released in 1947, starring John Mills and Joan Greenwood. The Odeon Hyland, which opened in 1947, was located at 1501 Yonge Street, on the east side, a short distance north of St. Clair.

I have many fond memories of this grand theatre. On a Sunday morning in 1959, a friend and I listened to a church sermon in which the movie *Room at the Top*, starring Lawrence Harvey and Simone Signoret, had been vociferously condemned. The preacher had given the film better publicity than the newspapers. After listening to the sermon, being teenagers, we decided that seeing the movie was a high priority.

The following Saturday evening, off we marched to the Hyland to see the X-rated feature. However, when we were leaving, we came face to face

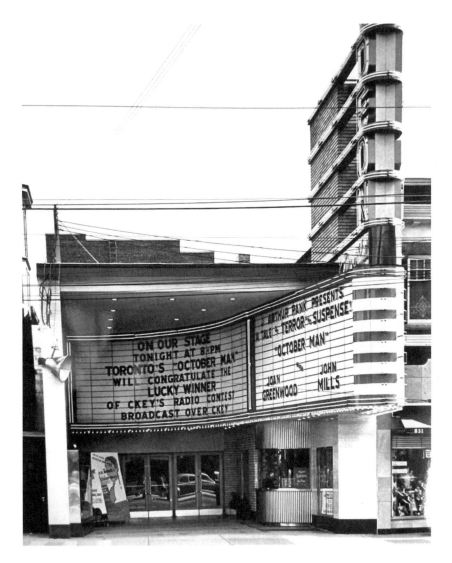

The Odeon Hyland Theatre, circa 1948. *Ontario Archives, RG 56-11-0-309.*

with one of the elders of the church, along with his wife. There were a few awkward moments, and then we all broke into laughter. We made a pact that no one would ever admit that we saw the movie. By the way, the movie was indeed "hot and steamy," at least that was the way we viewed it in 1963. In later years, I saw the movie on TV and failed to see why I had considered it so risqué. Time destroys more than just our youth.

Room at the Top was one of a group of films that became known as the "Kitchen Sink" movies. They were part of a British cultural movement that reflected the lives of working-class Britons. It began in the late 1950s and lasted until the end of the 1960s. Some referred to it as "angry theatre," while others considered it "social realism." It portrayed angry young men who lived in cramped, cheap accommodations and who spent copious time in local pubs. The first film in the genre was *Look Back in Anger* (1959). A few of the other films were *Saturday Night and Sunday Morning* (1960), *A Taste of Honey* (1960) and *Alfie* (1966). The final "Kitchen Sink" film was *Spring and Port Wine*, released in 1970. However, the genre continued in *Coronation Street* and *The Eastenders*. When I saw *Room at the Top* in 1959, I was not aware that it reflected a social/cultural movement in Britain.

In 1963, a friend and I visited the Hyland to see the movie *Tom Jones*, starring Albert Finny. It was based on Henry Fielding's novel *The History of Tom Jones*. It was considered a very risqué film. When the film opened at the Hyland, the lines were so long that the manager arranged to serve coffee to those waiting to purchase tickets. The movie told the story of a promiscuous young man in eighteenth-century England who lured into bed many of the women he encountered.

When a friend and I saw the film, there were three elderly women sitting behind us. They giggled and snorted each time Tom landed in the bed of another woman. The comments of the women were rather mild in nature, with an occasional, "Oh my goodness, "Mercy me" and "Oh my goodness gracious" being heard amid the giggles. However, when Tom ended up in bed with a woman whom he later believed to be his mother, the three ladies were silent. They departed the theatre shortly after, deciding that the film was perhaps a little too racy for their delicate sensibilities.

The Hyland's architect was Jay English, who also designed the Odeon Fairlawn and Odeon Carlton. The Hyland opened on November 22, 1948, with 884 seats in its auditorium and another 473 in the balcony. One of the Hyland's managers, Victor Nowe, won the Quigley Award three times, given annually to the manager who exhibited the best promotional activities. For the film *Tight Little Island*, based on the novel *Whiskey Galore*, Victor Nowe covered the outside of the theatre in plaid. The stunt was highly successful, as it caught the eye of those passing in cars on Yonge Street. *Tight Little Island* told the story of a shipwreck off the coast of Scotland. The ship's cargo was whiskey, which the villagers wished to retrieve. In another advertising gimmick, for the film *Bridge on*

the River Kwai, Victor Nowe placed an enormous model of the bridge in the theatre lobby.

The Hyland Theatre was eventually split into two auditoriums, to increase revenue. When the renovations occurred, the marquee was dramatically altered. However, this did not save the theatre, and sadly, it fell to the wrecking ball in 2003. The Odeon Hyland had been located a few doors south of the Hollywood Theatre. At night, the brightly lit marquees of these two theatres dominated the street. Toronto's darkened streetscapes have been diminished by the passing of these great neon displays.

NORTOWN

When the Nortown Theatre opened its doors on March 17, 1948, it was considered one of the most ultramodern theatres of its day. The theatre was located at 875 Eglinton Avenue West, a short distance west of Bathurst Street. Built for Famous Players Corporation, its construction was personally overseen by Jules Wolfe, supervisor of theatres for the company. The Nortown operated on a "first-run and first-date policy," meaning that the theatre booked the most recently released films at the earliest date they were available. The architect for the Nortown was A.G. Facey of Toronto, who also designed the University Theatre on Bloor Street West.

Although the Nortown was less impressive than the University, it had a stylish contemporary exterior, with large stainless steel framed windows on both the ground level and the second floor. The large window on the first floor, which covered one-third of the exterior, was slanted to provide an excellent view from the sidewalk of the interior lobby, with its built-in, deep-red seats. It was a "classy" theatre, meant to appeal to the upscale Forest Hill District where it was located. In John Sebert's book *The Nabes*, he referred to it as a "high-end Nabe," the term referring to a neighbourhood theatre.

The floor of the orchestra section was of concrete, in which dye had been added to the cement to colour it Venetian red. Because of the pigment, it never required painting. The auditorium contained almost one thousand plush upholstered seats, spaced wide apart for maximum comfort. There was no balcony, and the last ten rows were designated as the smoking section.

My memories of the theatre include seeing the 1951 film *The African Queen*, directed by John Huston and starring Humphrey Bogart and Katharine

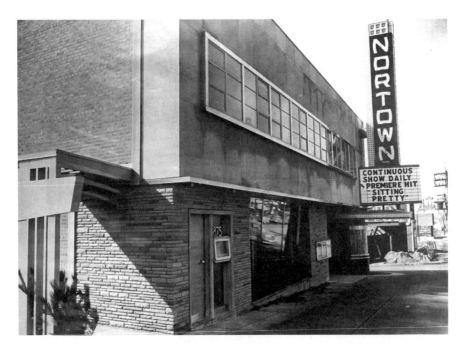

The Nortown Theatre in 1948. *City of Toronto Archives, Fonds 251, Series 1278, File 108.*

Hepburn, and, in 1952, *With a Song in My Heart: The Jane Froman Story.* Both movies are among my favourites when they appear on TCM.

In 1972, although the Nortown was still screening movies, it was put up for sale. It was advertised as 30,882.5 square feet, and the asking price was $890,000. It was eventually purchased and demolished in 1974. A mini-plaza was erected on the site.

WILLOW

The proposal for the Willow Theatre was submitted to the city in the autumn of 1945 by the architect Herbert George Duerr, but the theatre did not open until June 18, 1948. Duerr designed many theatres throughout Ontario, including the Hollywood Theatre on Yonge Street, north of St. Clair Avenue West, and the Scarboro Theatre on Kingston Road.

The Willow Theatre was located in the northern Yonge Street community of Willowdale, on the east side of Yonge Street, at the corner

of Norton Avenue. It was constructed to serve the needs of the new suburban residential community built after the Second World War. Its architecture was postwar modern, a dramatic departure from the more intricate designs of former decades, and was similar in style to other theatres built in the suburbs of Toronto in this decade. Its plain lines were created with moulded cement, its façade and cornice unadorned. It possessed an enormous glass-brick window on the ground floor, to the left of the row of glass doors. The decorative art on the façade was similar to the art on the walls of the auditorium. The theatre contained almost one thousand seats, but there were only two aisles, situated against the side walls, the rows containing thirty-four to thirty-five seats across. There were forty inches between the rows, which allowed extra leg room—or as the theatre boasted, "continental seating." It was a landmark in the community because of its yellow marquee and the prominent yellow signage above it. It was an island of colour on the commercial streetscape.

I was never in the Willow Theatre, but when I was a young boy, the father of a friend of mine was constructing a house in the area where it was located.

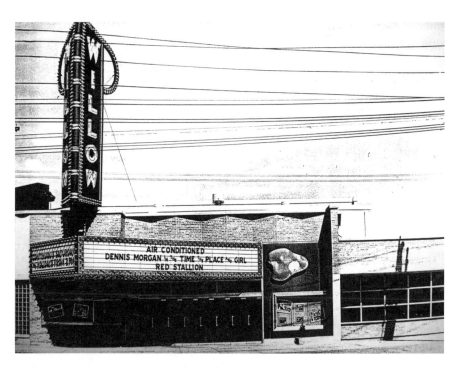

The Willow Theatre at 5269 Yonge Street, circa 1948. *City of Toronto Archives, Fonds 251, Series 1278, File 8.*

On long summer evenings, I accompanied the friend when his father worked at the site. The friend and I played in the fields to the east of the theatre, as in the 1940s, empty building lots were common in Willowdale. It was during these visits that I caught a glimpse of the Willow Theatre.

In March 1957, a "stink-bomb" problem developed at the Willow during the Friday evening shows. It continued for three weeks until the police arrested a seventeen-year-old. Such problems were common in theatres in this era.

In 1958, there was considerable outcry from the citizens of "Toronto the Good" against the movie *Peyton Place*, when it played at theatres across the city. Many considered it a shocking film. In December 1958, the film screened at the Willow. The situation became more outrageous as the second feature was *And God Created Women*. However, the manager said that there were no problems during the screenings, although he did receive a card written by the "Legion of Decency." On the card was scribbled, "This is not family entertainment." In fairness, I doubt that many families attended, as the movie was classified as restricted and was not exactly of the Walt Disney variety. I remember seeing the film when I was a teenager. I thought it was pretty tame, although some of the scenes with Lana Turner were really "hot."

The Willow continued longer than most neighbourhood theatres, but with diminished attendance and the increase in land prices in the area, the property was sold in 1987. The theatre was demolished, and a condo and offices are now located on the site.

DOWNTOWN

The Downtown Theatre at 285 Yonge Street opened in September 1948, constructed at a cost of $750,000. It contained 667 seats on the downstairs level and an additional 392 seats in the balcony. The lobby was spacious and possessed a polished terrazzo floor. During opening week, the attraction was *Let's Have a Little*, starring Hedy Lamarr and Robert Cummings. Screenings commenced each day at 9:30 a.m., and early patrons were offered a breakfast of coffee and a hot dog.

The theatre was located on the east side of Yonge Street, a short distance south of Dundas Street. Today, the site is the southern portion of the Yonge-Dundas Square. When viewed from Yonge Street, the height of the yellow-

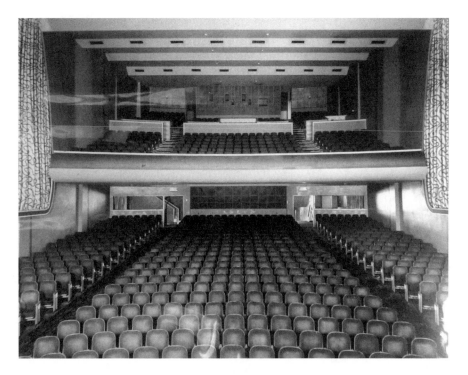

View of the interior of the Downtown. *Ontario Archives, RG 56-11-0-286.*

brick building indicated the size of the interior auditorium and balcony. The Downtown Theatre was never one of Toronto's premier movie houses, but along with the Biltmore, it offered a choice to those who wished to view a double feature, as opposed to the Imperial and Loew's Downtown, which offered only one feature.

During its thirty-year history, the film that grossed the highest revenues was *Al Capone* in 1959, starring Rod Steiger in the leading role. Another that created high revenues that year was *Hercules*, with Steve Reeves. Other long-running hits at the downtown included *So Young So Bad*, *The Joe Louis Story*, *Last of the Vikings*, *Devil's Angels*, *The Naked Prey* and *Wild in the Street*. At its height of popularity, the Downtown had a staff of forty-four employees: two managers, two projectionists, four cashiers, three doormen, twenty ushers, six food attendants, one building superintendent, five cleaners and one matron.

When I was about ten years of age, I journeyed downtown with my parents. Sometimes, when we returned home, it was nearing sunset. I remember

viewing the lights of the Downtown Theatre through the windows of a Peter Witt streetcar on Yonge Street. The magnificent marquee and flashing sign of the theatre soared high into the sky, its sparkling neon lights dominating the street, along with similar displays such as those of Loew's Downtown, the Imperial and the Biltmore Theatres.

Other fond memories of the Downtown Theatre are from my teenage years. I remember being entranced by the B-grade horror films and pseudo-horror movies such as *Abbott and Costello Meet the Mummy*. My friends and I thought that the famous comedians were very funny but that the mummy was terrifying. Life did not offer anything better than this until I was of age to attend restricted movies.

When the Downtown Theatre was demolished in 1972, the lightshow that illuminated Toronto's main street each evening was lost forever. With the demise of the marquees of the other old theatres, as well as the sign on "Sam the Record Man," the best neon display that remains is that of the Zanzibar Tavern.

ODEON CARLTON

The Odeon Theatre at 20 Carlton Street was the grandest of the theatres opened by the British Odeon chain. Originally named the Odeon Toronto, it opened on Thursday, September 9, 1948, and was advertised as "The Showplace of the Dominion." An enormous theatre with 2,318 seats, it contained an orchestra section on the main floor, a loges section (for smoking) and a balcony. The opening-night film was *Oliver Twist*, a British production from J. Arthur Rank Studios, starring Alec Guinness as Fagin.

The Odeon on Carlton was the first theatre in Canada to contain a restaurant, originally intended as a fine dining establishment. However, the congregation of the nearby Carlton United Church objected to it being granted a liquor license. This was 1948, and Toronto was a different city back then. As a result of the objections, a Honey Dew restaurant opened. It was not exactly fine dining, as apart from its trademark orange "Honey Dew" drink, it mainly offered Ritz Carltons (hot dogs) and fish and chips. However, it allowed patrons to enjoy a light meal and attend a movie without braving Toronto's bitter winter weather and summer's humid heat.

In 1948, ushers at the theatre were paid fifty cents per hour for a six-day workweek. By law, no movies were allowed on Sundays. Ushers earned

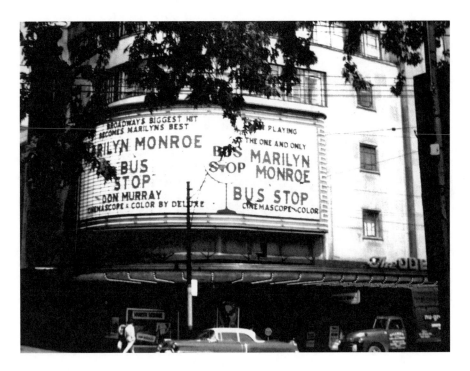

The Odeon Carlton, circa 1959.

ten dollars extra by changing the letters on the marquee that advertised the featured films. The large letters were made of aluminum, so they were not heavy to lift up and down. However, to change the letters, the usher climbed a ladder, which was attached to a track that curved around the marquee. The track held the ladder in place as it was moved to the various positions required to insert the letters on the marquee. On a windy winter day, it was dangerous work.

In 1953, an elderly lady climbed to the balcony to view the film *A Queen Is Crowned*, the official movie of the coronation of Queen Elizabeth II. The woman thoroughly enjoyed the experience, but when she departed, she told an usher that she was amazed that the theatre was able to fit so many people on the stage. She had thought that she had been watching a live stage performance.

The film *The Dark Man* was shown at the Carlton in 1951. To promote the movie, one of the ushers walked up and down Yonge Street wearing a large black hat and a mask. He handed out cards that read, "Is your number up? Check at the box office for a free pass." If the number on the card a person

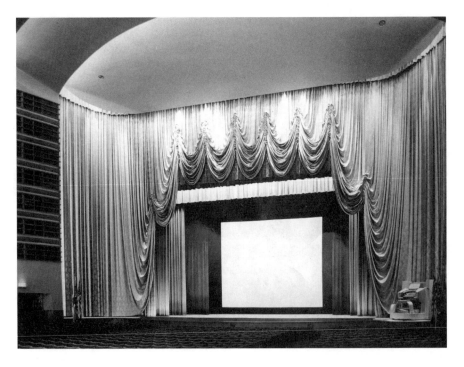

Main-floor level of the interior of the Odeon Carlton. *Ontario Archives, RG 56-11-0-305.*

received was included among the numbers that the cashier had listed as a winner, the patron received a free entrance ticket. It was a successful gimmick and drew many people to the theatre. The film was the story of a killer who had committed a double murder. A young aspiring actress witnessed the crimes and was marked for death by the killer.

In 1954, the grandstand show at the CNE featured Roy Rogers and Dale Evans. One of the afternoon performances was cancelled due to rain. The grandstand stars were quietly ushered into the Odeon Carlton by a side door to view the film *Magnificent Obsession*, starring Rock Hudson. Walter Godfrey, who was the assistant manager at the time, allowed them into the theatre. As a reward, he was given a free ticket to the grandstand show and a ten-gallon hat. In 1956, the name of the theatre was changed from the Odeon Toronto to the Odeon Carlton.

During the 1950s, Hollywood star Dorothy Lamour performed on stage at the Carlton for a week. She was best known for the *Road to...* movies (Bali, Rio, Hong Kong and so on). At the Carlton, she appeared alongside the popular quartet the Four Lads. I remember attending one of these performances and was amazed how glamorous Miss Lamour appeared. On

the closing Saturday night, they held a party for the cast and the employees of the theatre. It was held on the stage and was catered by Shopsy's.

In 1964, I saw the movie *Goldfinger* at the Carlton. The thrill of the James Bond film was greatly enhanced by the theatre's enormous screen and excellent sound system.

When attendance at the theatre diminished, it was no longer profitable to operate a venue the size of the Carlton. The building was offered to the City of Toronto for one dollar, but the city refused, as it could not afford to maintain it. Sadly, the theatre was demolished in 1974.

I am grateful to Walter Godfrey for much of the information on the Odeon Carlton. He worked at the theatre as an usher and eventually became the assistant manager.

DONLANDS

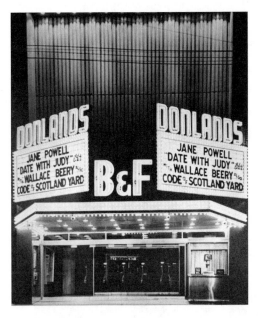

The Donlands Theatre in 1949. *Ontario Archives, RG 56-11-0-285.*

The Donlands Theatre, located at 397 Donlands Avenue, near Plains Road, was designed by Herbert Duerr, the architect for the Hollywood and Willow Theatres. Similar to the Willow Theatre, he chose a modern style for the Donlands, with sleek lines and a wide entrance containing large glass doors. The auditorium had more than eight hundred seats, including the loges, but no balcony. The B&F chain owned and operated the theatre, with its first manager being Martin Bloom.

Excavations commenced on April 15, 1947, but the opening of the theatre was delayed due to a plasterers' strike. It finally opened on November 20, 1948, and was an immediate hit. Saturday afternoon matinees commenced at 1:30 p.m.,

131

and if a restricted movie were on the marquee, a substitute was shown at the matinees. The theatre was renovated in the years ahead by Kaplan and Sprachman, Canada's most famous architectural firm for theatres. A confection bar was added, but it sold no popcorn. For a period in the 1970s, the theatre showed East Indian films.

I was unable to discover when the Donlands closed, but after it ceased to operate as a theatre, it was rented as studio space.

Biltmore

The Biltmore Theatre seated almost one thousand patrons, twice the capacity of the Rio Theatre, which was located farther north on Yonge, closer to Gerrard Street. The Biltmore had problems booking recently released films, since the Imperial and Loew's Downtown to the south of it had larger capacities and were more profitable for screening up-to-date Hollywood releases. To compensate, the Biltmore was another of the theatres that

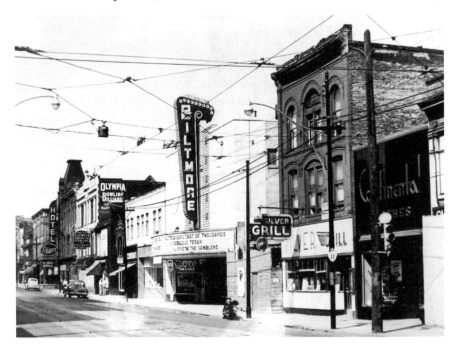

The Biltmore Theatre on January 3, 1950. *City of Toronto Archives, Series 574, File 003, Item 49412.*

offered double and sometimes triple features at a low price, sometimes as cheap as one dollar if you entered before 6:00 p.m. As the theatre declined, it offered better bargains to entice patrons (like five films for three dollars, including martial arts films, action flicks and soft porn). Although the latter films were restricted, the doorman did not check IDs very carefully. My friends and I rarely attended the Biltmore, since our neighbourhood movie houses satisfied our need to view older films, although they never showed porno films.

The Biltmore, with its impressive sign and marquee, was on the east side of Yonge Street, a short distance north of Dundas Street. To the north of the theatre was the Le Coq d'Or cocktail lounge. Beside it, on its northern side, in the photo of the theatre can be seen the turret on the Edison Hotel. It had previously been named the Princess Hotel, and it burned on January 3, 2011. Only the walls of the building remained, and its north wall eventually collapsed into the street.

The Biltmore closed in 1986. The site was used for various commercial enterprises until it was demolished in 1991 to construct the twenty-five-thousand-square-foot HMV Superstore, located in the building at 10 Dundas Street East.

ODEON HUMBER

In the years following the Second World War, the terminus of the Bloor Streetcar line was at Jane Street. In this decade, the community to the north and west of this intersection was expanding as more housing was required to accommodate the city's increasing population. These factors made the Bloor/Jane area an ideal location for a movie theatre. As a result, in 1948, the Odeon chain decided to build a new modern theatre in the area—the Odeon Humber. It was to be another in the chain of theatres that the company owned—the Carlton, the Danforth, Fairlawn and the Hyland.

My own personal memories of this theatre are rather embarrassing. One Saturday evening, I attended a double-bill screening. When purchasing a soda drink from the vending machine in the lobby, I inserted my coins, but nothing happened. In frustration, I gave the machine a whack with my fist, and this brought an angry response from the manager. I slinked into the auditorium with my popcorn but no drink. I was soon immersed in the film and forgot about the great financial loss that I had suffered—well, I never

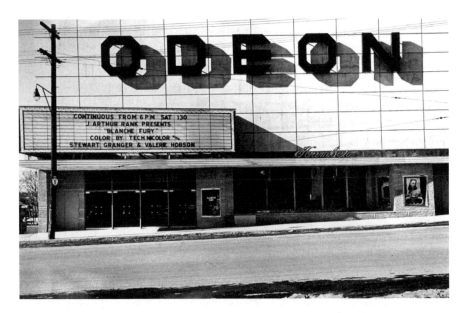

The Odeon Humber in 1949, located at 2442 Bloor Street West, a short distance to the west of Jane Street. *Ontario Archives, RG 56-11-0-308.*

completely forgot, as forty years later I still remember the incident. By the way, the drink that I had attempted to buy was a Tahiti Treat, made by Canada Dry. This drink has long since disappeared from the scene, along with the Odeon Humber.

As theatre attendance diminished, the Odeon Humber was partitioned into two theatres in an attempt to draw larger crowds. In 1999, more than $400,000 was spent to install larger seats, digital sound, new carpets, expanded washroom facilities and a new concession stand. However, the Odeon chain closed the theatre in 2003, and for several years it was vacant. In April 2011, it was reopened by Rui Pereira, the owner of the Kingsway Cinema. It is now named the Humber Cinemas and has four screening areas.

TOWNE CINEMA

The film on the marquee of the Towne Cinema Theatre is *Goodbye Columbus*, a romantic comedy released in 1969. It starred Richard Benjamin and Ali McGraw in their Hollywood debuts. The photo indicates that the film was in its twenty-second week at the theatre.

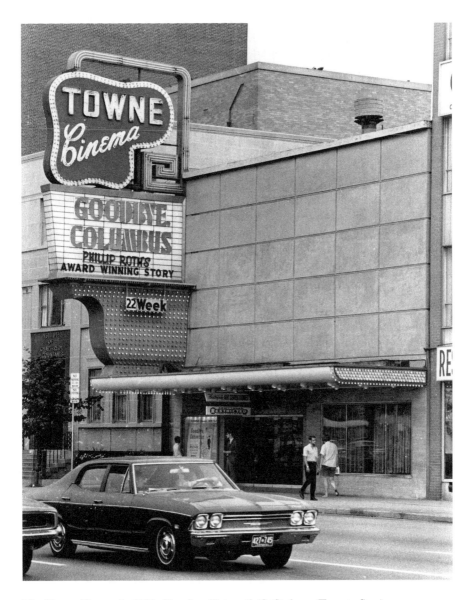

The Towne Cinema in 1969. *Photo from Photograph/GetStock.com (*Toronto Star*).*

Information on the Towne Cinema is scarce in the archives, but I remember this theatre quite well. Located at 57 Bloor Street East, it was on the south side of the street, a short distance east of Yonge. It specialized in art films, although it offered other movies as well. I saw several film adaptations of Shakespeare's plays at the Towne Cinema. If I remember correctly, tickets

for these films were available in advance of the performances and could be purchased from ticket companies throughout the city. The tickets designated the exact seats, similar to legitimate theatres such as the Royal Alexandra. This added a degree of prestige to attending the Towne Cinema.

The theatre opened on April 25, 1949; it was an intimate venue with only 501 seats in its auditorium and another 192 in the balcony. Because the balcony was located above the lobby that fronted on Bloor Street, it was recessed back a considerable distance from the screen. The Towne Cinema's façade, designed by Kaplan and Sprachman, was modern, with sleek, smooth lines; it included large glass windows across the front. The seats in the theatre were supplied by the Canadian Theatre Chair Company, located on St. Patrick Street in downtown Toronto. The Towne Cinema was owned and operated by the 20th Century Theatre chain. Its sister theatre was the International Cinema at 2061 Yonge Street.

The theatre closed in 1985, and the premises were converted for other retail purposes. I remember when the site was a drapery and fabrics store. The building was eventually demolished, and the land it occupied is now part of the condominium (One Bloor) on the southeast corner of Bloor and Yonge.

THE 1950s THEATRES

The 1950s was a decade when Toronto's movie theatres continued to dominate the entertainment scene, their only serious rival being the hockey games at Maple Leaf Gardens. It was also the decade when drive-in theatres were introduced to the city, the first being the Dufferin, north of Steeles Avenue. That theatre even contained a swimming pool behind the screen. Drive-in theatres combined the movie craze with the love of the automobile. On hot summer nights, there were few experiences more glorious than attending a drive-in. Most people who attended them have stories of trying to sneak a friend inside the gates by hiding him/her in the trunk of a car.

Of course, the question most asked by older people was, "Why do young people always have a blanket on the back seat when they enter a drive-in, even in hot weather?" A good question indeed!

No one would ever have predicted that by the end of the decade, movie theatres would lose their popularity, replaced by viewing films on TV in the privacy of the home.

CORONET (SAVOY)

The Coronet Theatre at 399 Yonge Street was on the northeast corner of Gerrard and Yonge Streets. Originally named the Savoy, it opened on

February 15, 1951, as an ultramodern addition to the Biltmore chain. The architect was S. Devore of Toronto. The first film screened at the theatre was a double-bill—*Mr. Universe*, starring Bert Lahr and Robert Alda, and *Tough Assignment*, with Don Barry and Steve Brody.

In 1963, the Odeon chain leased the theatre and changed its name to the Coronet. In 1978, the theatre was seized by the sheriff of York County; it is assumed that this was for nonpayment of either the mortgage or taxes. Real estate prices were high on Yonge Street, and it was reported that mortgage payments on the building were $20,000 per month. The seven-hundred-seat theatre was sold, and it became a no-frills theatre, showing five movies for the admission price of $3.50, with the films commencing at noon. The movies were often violent, but fortunately there were few reports of problems with customers. However, during the showing of a Led Zeppelin film, the projector broke down and there was almost a riot. The police were called, but not before a young girl at the candy counter yelled at the rowdy crowd, "Shaddap and sid-down!" In 1980, the theatre had a 3-D fest.

It was said that during the latter days of the theatre, patrons brought in pizza, chicken, beer, liquor and even a few pets. Just to clarify, the pets were not part of the menu.

In 1983, the theatre was sold for over $1 million, and the building was converted into a mini-mall for jewellers. This necessitated gutting the building. The walls were retained, but windows were added on the second floor. There were fifty-eight booths for jewellers in the space that had once been the theatre's auditorium. Above them were twenty offices for gemologists and diamond setters.

The shell of the building remains today, a reminder of the theatre that it once contained.

WESTWOOD

The Westwood Theatre was at the intersection of Bloor, Dundas West and Kipling Avenue, the intersection known as "six points," a triangular piece of land sandwiched between three arterial roadways. The theatre's design was more utilitarian than aesthetic, as it was a simple architectural box. Designed by Kaplan and Sprachman, it was located in a mini-mall.

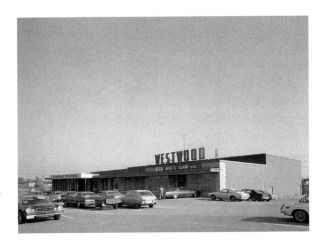

The Westwood Theatre at 3743 Bloor Street West. *City of Toronto Archives, Fonds 1257, Series 1057, Item 8480 (1).*

The expansive parking lot in front of the theatre had great appeal in postwar suburban Toronto, where by the early 1950s the automobile was becoming the king of the road. The Westwood was one of the first Toronto theatres constructed purposely to appeal to suburbanites with cars. The concept of a theatre within a mall, with enormous parking facilities, became the wave of the future. Today, this formula is copied throughout many urban areas and remains the preferred method of theatre construction in communities not well serviced by public transportation.

The Westwood opened to great fanfare on February 28, 1951, in a ceremony presided over by Leslie Frost, the premier of Ontario. The featured films were *Laughter in Paradise* with Alastair Sim and *You Never Can Tell*, starring Dick Powell and Peggy Dow. The theatre's auditorium contained almost one thousand rubber-foam cushion seats. It also possessed Canada's first "floating screen," which meant that hidden behind the screen were panels that separated it from the wall, creating the illusion that it was floating. It was more of an advertising gimmick rather than any real advancement in theatre design. The theatre's owner was United Century Theatre Ltd., but the license was held by 20th Century Theatre Corp. The first manager of the Westwood was Dudley Dumont.

I remember attending the theatre many times. The first automobile I ever owned was a flaming red 1963 Pontiac Acadian. I was very proud to have "wheels," and on a Friday or Saturday evening, sometimes I drove to the Westwood with friends. The large parking lot did indeed encourage us to attend. The theatre did not screen first-run films, so it offered a double-bill

to compensate. I recall that the lobby was spacious, and I never noticed that the architecture and interior were rather plain, especially compared to the theatres located downtown.

The theatre closed in 1998. I do not know if at one time it was ever converted for other purposes, but the building did remain vacant for many years. It was finally demolished in 2013.

TORONTO'S MODERN THEATRE SCENE

In some respects, the modern theatre scene in Toronto has reverted to a concept that was successful in the first decade of the twentieth century. Theatres are again located in leased premises within a large building. Today, it is rare for a stand-alone theatre to be constructed. Most theatres, in both the suburbs and in downtown Toronto, are included in larger complexes, usually in shopping malls or office/retail buildings.

Another feature of the modern era was the introduction of multiscreen venues. This began when theatres with one large auditorium were converted into several smaller auditoriums and sometimes the balconies into a separate venue. Theatres that were converted in this manner included the Imperial, Loew's Uptown and the Hollywood. However, the concept was expanded when the Cineplex Odeon Eaton Centre was built.

The idea of multiplex theatres soon spread, and by the 1990s and the first decade of the twenty-first century, although the number of theatres in Toronto had declined, the number of movie screens actually increased. Cineplex Cinemas Yonge-Dundas and Scotiabank Theatre Toronto are two excellent examples. These theatres share the buildings where they are located with other tenants. This model is employed in the downtown core of the city, as well as in the suburbs. The few stand-alone theatres that remain in Toronto are mostly survivors from the past—the Royal, Humber Cinemas, the Revue, Mount Pleasant, Regent and the Fox.

Cineplex Odeon Eaton Centre

By the 1970s, the downtown section of Yonge Street had deteriorated, especially between College and Dundas Streets. When the Eaton Centre opened in 1979, the area south of Dundas was revived. The new mall was instantly popular with Torontonians and attracted thousands of tourists as well. On the northwest corner of the Eaton Centre was a ten-storey parking garage. In the basement of the garage was a twenty-five-thousand-square-foot space that attracted the attention of Nathan A. Taylor (Nat) and Garth Drabinsky. They formed the Cineplex Odeon Corporation in 1979, as they realized the possibilities of the space in the Eaton Centre as a site for a movie theatre complex. It was in the heart of the city at Yonge and Dundas and easily accessible by public transportation. The area had much foot traffic as well.

To create the theatre complex, it required converting the huge space below the parking garage into a series of small theatres, all under the same roof. They coined the name "Cineplex" for the theatre—a contraction of "cinema complex." It was a revolutionary concept that established the pattern for movie theatres of the future.

The architect was Mandel Sprachman, who had restored the Elgin/Winter Garden Theatres. He had considerable experience in converting large theatre auditoriums into smaller venues, as he had redesigned the Imperial and Loew's Uptown Theatres into multiscreen complexes. This new method of presenting films allowed several movies to be shown in the same building, catering to the different tastes of viewers. Thus, it generated increased revenue without increasing costs for rent, taxes and heating. Nathan Taylor also had experience with operating multiscreen complexes, as he had opened one in Ottawa and had previously divided the Uptown Theatres into the Uptown 5.

Cineplex Odeon Eaton Centre was a natural extension of the multiscreen concept. When it opened on Tuesday, April 17, 1979, it contained eighteen auditoriums, each containing 50 to 100 seats—about 1,500 seats in total—the largest movie theatre complex in the world at that time. The auditoriums were grouped into four sections, located on two different floors. A rear-projection system was employed to screen the films, which caused the edges of the pictures on the screen to be slightly blurred. Few patrons seemed to notice, as the auditoriums were attractive and the seats comfortable. The aisles were on both sides of the auditoriums, which meant that no seats were jammed against the walls.

Lobby of the Cineplex Odeon Eaton Centre. *City of Toronto Archives, Series 881, File 251.*

The main lobby was capable of holding two hundred people, designed to resemble a "Common Room" where patrons were able to gather before attending a movie or linger after a film. A café and bistro were included, offering a wide variety of foods, and the walls displayed Canadian art. Computerized ticket-vending machines were installed, and it was possible to purchase tickets in advance, even a day or two ahead. By employing these machines and by staggering the times the movies started, crowding was reduced. No tickets were sold after a film began, preventing interruptions during viewings. A year or two later, the tickets were colour-coded, with eye-catching directional signs on the theatre walls to guide people to the appropriate auditorium. In 1981, three more auditoriums were added to the complex, bringing the total to twenty-one and the total number of seats to more than two thousand.

In the early years, the Cineplex Odeon Eaton Centre offered specialty films and foreign films, many of them with subtitles. It was not profitable to screen these in larger theatres, as the appeal of a single movie might be quite small. However, in smaller auditoriums, even if only thirty to thirty-five patrons saw a film in an evening, it remained profitable. To

further reduce costs, the theatre dealt directly with foreign producers or distributors to get Canadian rights. Films that were popular were shown in more than one auditorium.

The Cineplex Odeon Eaton Centre opened at a time when movie theatres were struggling, since home video players were becoming popular. Another difficulty was that competing theatre chains monopolized film distribution rights in Canada. Cineplex Odeon Corporation threatened to sue under the anti-combine laws and succeeded in loosening the stranglehold of the two chains. Thus, in the 1980s, Cineplex Odeon Eaton Centre was able to offer major Hollywood releases, similar to the theatres in malls of today. Having gained success, the multiplex idea was expanded across Canada and into the United States.

In its glory days, the complex in the Eaton Centre allowed patrons a wide range of movies, all in one building. Teenagers took great delight in trying to slip into another auditorium after they had seen the movie they had first paid to view. Movie buffs viewed films not available in larger theatres, as well as current Hollywood hits. At the confection stand, popcorn and other treats were available, and thanks to the idea of Garth Drabinsky, the popcorn was buttered. This was the first time that buttered popcorn had been available in theatres. This was another "Toronto first."

During the 1990s, viewing films on small screens became less popular as television sets increased in size and the quality of home videos improved. With the decrease in revenues, Cineplex Odeon Eaton Centre slowly deteriorated. The seats and carpets became tattered, and the auditoriums appeared shabby. To attract customers, films were offered at bargain prices, and special deals were advertised. However, these attempts failed, and the theatres began to attract the street crowd, such as those who attended the Rio Theatre on Yonge Street. They were seeking a warm place in winter and a place that was air conditioned in the summer. In their eyes, the multiplex theatre was a twenty-one-room hotel, each room having many seats in which to sleep and a huge TV screen to watch movies. The price of entrance and the location made it ideal for their purposes.

Attendance continued to dwindle. The final nail in the coffin was the opening of the multiscreen AMC at Yonge and Dundas in 2000. Cineplex Odeon Eaton Centre closed on March 12, 2001, and was demolished shortly after.

Cineplex Odeon Varsity Cinemas

Cineplex Odeon Varsity Cinemas are today on the second floor of the Manulife Centre, at the busy intersection of Bloor and Bay Streets. The theatre in the fifty-one-storey building was renovated in 1998 to create the Cineplex Odeon Varsity Cinemas, with eight auditoriums and four VIP screening venues. It was the first theatre in the city to offer small-screen theatres that were licensed for alcoholic drinks, with VIP service that delivered food and beverages from the snack bar directly to the patrons' seats. I saw the James Bond film *Quantum of Solace* in one of the VIP theatres in 2008 and was impressed. The Cineplex chain now has VIP Cinemas in its theatre at the Queensway, and several more are under construction at other venues (as of 2014). Cineplex Odeon Varsity Cinemas presently has twelve screens, as well as 3-D projectors.

The hallways and lobby of the Cineplex Odeon Varsity Cinemas are not as elaborate as some of the other Cineplex theatres. They contains little

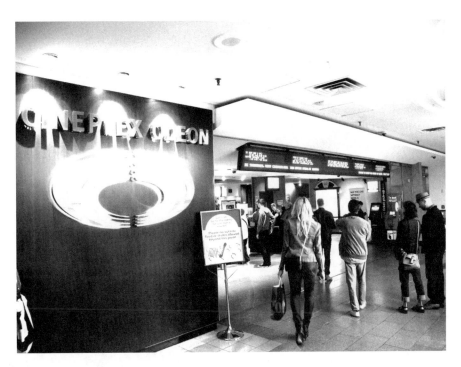

Entrance to the Cineplex Odeon Varsity on the second floor of the Manulife Centre.

artwork other than numerous movie posters and a large aquarium. However, it is a comfortable and well-located venue that is likely to remain popular. It screens the latest movies and continually draws crowds to its auditoriums, especially on weekends.

An article written by Adam Meyes on June 10, 2013, in the Business Section of the *Toronto Star* provided information about Cineplex Entertainment. He wrote that in that year, the company controlled 70 percent of the movie screens in Canada, even though it did not operate east of Quebec. However, Cineplex finally absorbed the Famous Players chain and also purchased four complexes owned by AMC Corporation. One of these was the AMC Theatre at Yonge and Dundas. In November 2013, Cineplex Entertainment extended beyond Quebec by acquiring twenty-four Empire Theatres in Atlantic Canada.

SCOTIABANK THEATRE TORONTO (CINEPLEX)

The Scotiabank Theatre Toronto was originally named the Paramount Theatre. Its name was changed to the Scotiabank Theatre Toronto in a deal that created the customer loyalty programs of Cineplex Entertainment and Scotiabank. The theatre's modern architecture is perhaps jarring to the eye when first viewed, but it is an impressive structure that dominates the scene like no other building in the area. At night, its neon lights, similar to the grand marquees of theatres of old, such as the Imperial and Loew's Downtown, shine into the night, illuminating the street.

The theatre occupies only the top section of the building where it is located. The theatre's lobby is ultramodern, its design incorporating glass, steel and neon lights, whereas in older theatres, ornate plaster trim, stone carvings and decorative marble were employed. The escalator that leads to the second-floor level, where the auditoriums are located, may not be as grand as the entrance staircase in the Ed Mirvish Theatre (the old Imperial), but its immense height creates a sense of awe, as it is one of the tallest escalators in the country.

At the Scotiabank Theatre Toronto, the experience begins the moment you enter the building. Modern sculptures and art hang from the ceiling of the lower lobby, adding to the appeal of the vast space. The upper lobby has a modern-style chandelier and numerous mirrors that reflect daylight from the wall of windows facing John Street.

The multiscreen Scotiabank Theatre at 259 Richmond Street West, built in 1999.

The numerous auditoriums in the theatre contain stadium seating, a feature that is a vast improvement over the theatres of old. The seats are comfortable, with cup holders on the armrests to place drinks. In the old days, commercials were rare in theatres. Today, to avoid the endless advertising, some people enter a theatre about twenty or twenty-five minutes after the listed starting time of the film. However, theatres today still employ free gifts to entice people to attend. No dinnerware or autographed photos of movie stars are offered. A person now answers trivia questions on an app on a cellphone. The prize is a pizza, a new twist on an old technique.

The Scotiabank Theatre Toronto is also one of the most popular venues during TIFF. Each year, thousands of people attend the Scotiabank Theatre's many auditoriums to view films.

CINEPLEX CINEMAS, YONGE-DUNDAS

The Cineplex theatre at Yonge and Dundas is located within the retail complex at 10 Dundas Street East, on the northeast corner of the intersection at Yonge and Dundas Streets. It was officially opened on March 28, 2000. The theatre was operated by AMC but was eventually purchased by Cineplex Entertainment.

I admit that when I first examined this building, I thought that I was gazing at an enormous electronic billboard. Christopher Hume of the *Toronto Star* once referred to it as "horror architecture." Its gaudy, scattered array of signs almost obliterates the building.

The structure has an L-configuration, as it wraps around preexisting structures, its curved façade conforming to the shape imposed by Dundas Street. The building overlooks the Yonge-Dundas Square, one of the main squares of the city. In the summer, it is a delight to sit in the chairs in the square, under the shade of an umbrella and read a newspaper, send or receive text messages or check e-mails while enjoying a cup of coffee. The building at 10 Dundas Street East, when viewed from the square, may appear as

The Cineplex Cinemas at Yonge and Dundas.

if it is a mass of electronic signs. However, this does not detract from the magnificent theatres within. In some respects, the lobbies of the complex are as impressive as the grand movie theatres of the 1940s and 1950s.

The entrance to the theatre complex at 10 Dundas Street East is below the sign for the movie theatre. The box office was originally on the ground floor, but it was eventually moved up to the fourth floor, where the theatres are located. Patrons ascend on the escalators to gain entrance to the theatre. Exiting the escalator and approaching the lobby, patrons are confronted by an expansive space, decorated with neon lights and sweeping displays of metal and glass. The upper lobby is smaller, with more subdued lighting and modernistic curved lines. Similar to the theatres of yesteryear, the Cineplex Cinemas Yonge-Dundas attempts to create the feeling that your entertainment experience begins the moment you enter the theatre. Personally, I believe that it succeeds.

BELL LIGHTBOX

I remember when the site of the Bell Lightbox, the headquarters of the Toronto International Film Festival (TIFF), was a parking lot. I am also able to recall the excitement when the newspapers announced that a permanent home for the festival was to be built, designed by the architectural firm of Kuwbara Payne McKenna Blumberg (KPMB). Until it was completed, the festival's offices remained in several different buildings in the downtown area. The new headquarters would allow TIFF's support facilities to be located in a single place. Another difficulty prior to the construction of the new building was that the screening venues for the festival were scattered from Bloor Street in the north to King Street in the south. Since the new structure was to be in the heart of the city's entertainment district, it was hoped that the festival's screening venues would eventually cluster around it. This did indeed occur.

After construction began, I anxiously watched the storeys rise, one after the other. Located at 350 King Street West on Reitman Square, on the northwest corner of John and King Streets, the building soon towered to a height of forty-six floors. The name "Bell Lightbox" seemed appropriate, since Bell Corporation was a major financial contributor, and the word *lightbox* refers to an early name for a camera.

It opened on September 12, 2010, the thirty-fifth-anniversary year since the inauguration of the festival, when a massive street party was held on

King Street. It featured live performers and concerts, becoming a gala that lit the night until the early morning hours. The TIFF Lightbox is contained within the five-storey podium of the forty-six-storey tower, its entire space dedicated to film, including screening as well as archival and educational facilities. Above the Lightbox is a hotel/condo complex named the Festival Tower, set back from the street, with a separate entrance at 80 John Street. When sales commenced for the condos, rumours spread in the press and on the social media that Hollywood stars were purchasing condo units in the tower to provide accommodations and entertainment suites during the festival. However, the identities of the stars were kept a secret. These stories added to the mystery and glamour surrounding the building.

The TIFF Lightbox contains five cinemas, three studios, two restaurants, the Film Reference Library, a gift shop, two art galleries, a licensed lounge and a museum-quality display gallery. The members' lounge is on the second floor, on the southeast corner of the building, with panoramic views of the street below, where colourful streetcars ramble along the crowded avenue. The lobby is the equivalent of three storeys in height and contains an exceedingly high escalator that ascends from the lobby to the second floor. The south façade of the podium contains sheets of glass that during the day reflect the ever-changing panorama of historic King Street, and at night, its interior lights illuminate the streetscape like a giant beacon.

The theatres in the complex are among the most comfortable in the city. The rows are steeply sloped to create stadium seating, ensuring that each seat possesses an unobstructed view of the screen. The Lightbox owns five types of 35mm cameras, as well as one that is 70mm.

I toured the building after it opened in 2010 and was impressed. However, I must admit that I had never attended the festival itself. I had resisted because I did not enjoy lineups and did not wish to sit in a dark theatre on a sunny late summer day. However, in 2011, a friend had an extra ticket for a screening of a South Asian film at TIFF and offered it to me. I attended and thoroughly enjoyed the experience, particularly the discussion with the stars of the film following the screening. The next day, I purchased tickets to view a movie at the Elgin, and upon arrival at the theatre, my friends and I were dismayed at the length of the lineup. However, when the doors opened, the lines entered within minutes. The organization of the event by the volunteers was amazing. My resistance to attending TIFF crumbled. I purchased a membership that I intended to use for the following year's festival.

Each year since, I have faithfully attended TIFF and now consider it one of the highlights of my year. Several weeks prior to the festival, I purchase

The TIFF Lightbox and the Festival Tower Hotel/Condo above it during the summer of 2012. The view gazes west on King Street.

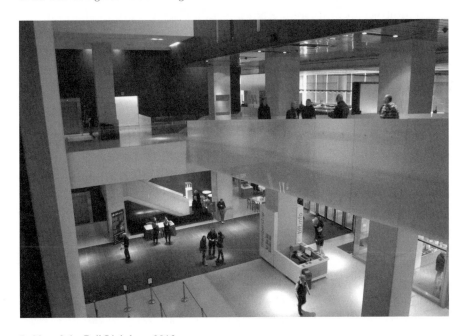

Lobby of the Bell Lightbox, 2012.

a package and choose the films I wish to see. I tend to avoid the popular Hollywood films, as they will arrive in the regular theatres at some point following the festival. Instead, I concentrate on foreign movies and films that I might otherwise never have an opportunity to see. I choose mainly evening performances to enable me to continue enjoying September's late summer days. This approach works well for me, although it would not be everyone's method of choosing movies. I am now hooked on TIFF.

The atmosphere on King Street during the festival is amazing—a wild kaleidoscope of colour and motion. While attending the various screenings, I have enjoyed conversations with strangers during the short waiting times before the theatre doors open. Inside the theatres, while waiting for the movies to begin, people invariably chat with me and share opinions about the films they have seen.

My visits to the Bell Lightbox are not restricted to when TIFF is in operation. I attend films there throughout the year. Viewing movies in its theatres is akin to attending a live theatrical performance, whether it is a movie classic from yesteryear, a foreign film, a recent Hollywood release or an art film. One evening, I went to see a film about the painter Tom Thomson and was surprised to see that the theatre was full. On another occasion, I viewed *2001: A Space Odyssey*, seeing it as it was intended, with a 70mm projector and Dolby sound. Another night, a group of us saw the 1979 film *Love at First Bite*. The movie was corny and delightfully campy. Great fun! After the movie, the star of the film, George Hamilton, appeared and answered questions. The same group of friends also saw *Jaws*, and after viewing it on the big screen, we rediscovered what a terrifying film it was. The Bell Lightbox has become a regular haunt for us, as it offers a wide range of films and experiences 365 days a year.

The Bell Lightbox is now an integral part of the Toronto scene. It participates in various events of the city. During the summer of 2012, the City of Toronto placed secondhand pianos throughout the downtown area and encouraged people to perform on them. Artists decorated the pianos, each one representing a country that would be participating in the 2015 Pan Am Games. The piano representing Costa Rica was in the lobby of the Bell Lightbox. Each year during TIFF, the Bell Lightbox is crowded with those who remain in love with the big-screen experience, even if it occurs within one of the smaller venues in the building.

Toronto is greatly enriched by the presence of the Bell Lightbox, home to one of the world's greatest film festivals.

CONCLUSION

Reality is anything we want it to be. This is readily evident when listening to older folks reminiscing about the exploits of their youth or younger people relating happenings at a recent concert or party. As time passes, memory tends to exaggerate, making fibbers of us all.

I suppose I must apply this to the theatres mentioned in this book and the events surrounding them. Toronto's old movie theatres, with their big-screen formats, swept me into a world of wonder that I shared with the audiences surrounding me. Electronic devices cannot provide this feature. The silver screen illuminated the past and provided a glimpse into the future. Thanks to Toronto's old movie houses, I felt that I knew the heroes of Hollywood personally, and when I was a child, I wished to emulate them. What boy did not want to be Cary Grant, John Wayne or Roy Rogers? What girl did not want to be Veronica Lake, Rita Hayworth or Jane Russell, the sweater girl who inspired the uplift bra?

The movie theatres played an important role in the social history of Toronto. Their architectural styles and the films they screened, as well as the regulations they imposed on those who attended, reflected the social attitudes, trends and moral standards of the various decades. Those of us who experienced them may lament their passing, but in memory, they will live on. It is hoped that this book will play a small role in this endeavour.

INDEX

ABOUT THE AUTHOR

Doug Taylor has researched, studied and taught the history of Toronto for several decades. This is his seventh book that employs his native city as the background for his writing. Having taught history at the high school level, Doug was a member of the faculty of Lakeshore Teachers' College (York University) and the Ontario Teacher Education College. Now retired, he lives in Toronto.

ALSO BY DOUG TAYLOR

Lilies of the Covenant
The trials and joys of five generations of the Taylor family, in eighteenth-century England, nineteenth-century Newfoundland and twentieth-century Toronto.

Citadel on the Hill
A history of a church community in Toronto in the first decade of the twentieth century, chronicling the trials and successes of the congregation as it progresses into the modern era.

The Pathway of Duty
An immigrant family from England arrives in Canada in the early years of the twentieth century and struggles to survive in the harsh conditions of Toronto's Earlscourt District. The sinking of the *Empress of Ireland* in 1914, in the icy waters of the St. Lawrence River, dramatically changed their lives forever.

There Never Was a Better Time
Two young brothers immigrate to Canada in 1920, and the remainder of their family soon follows them. The adventures of the brothers provide a humorous and intimate glimpse into family life in Toronto during the Roaring Twenties. The book also relates the antics of their younger brothers, parents and rascal of a grandfather.

Arse Over Teakettle (Toronto Trilogy, Book One)
An intriguing tale of two young boys, their coming of age and becoming sexually mature in Toronto during the stressful years of the Second World War. Tom Hudson and his mischievous friend "Shorty" are the two main characters. They find adventure in the seemingly quiet laneways of their neighbourhood as they attempt to learn the secrets of the older boys and yearn to participate in their activities.

The Reluctant Virgin (Toronto Trilogy, Book Two)
In 1950s Toronto, a killer brutally murders a young woman in the seclusion of the Humber Valley. It is discovered that her body was drained of blood. Her death threatens the seemingly secure world of Tom Hudson when he discovers that the victim was a teacher at his high school. The police are unaware that they are confronting a clever and dangerous serial killer.

When the Trumpet Sounds
A poignant tale of a family that immigrates to Toronto in the first decade of the twentieth century. Their mischievous eldest son develops an interest in music and becomes a member of a Salvation Army band. He travels to England with his younger brother and his father, but tragedy awaits them when their ship is rammed by another vessel as it sails down the St. Lawrence River.